VAN GOGH'S
La CROQUEUSE *du* JARDIN:

Letters from Provence

VAN GOGH'S
La CROQUEUSE
du JARDIN:

Letters from Provence

SHELLEY R. HAMILTON

WOW! Press • Chicago, Illinois
wowpressonline.com

WOW! Press
Chicago, IL
wowpressonline.com

© 2017 by Shelley R. Hamilton

WOW! Press • Chicago, Illinois
wowpressonline.com

Printed in the United States of America

ISBN-13: 978-0-99745-381-2

Editor's Note

In September 2005, the Vincent Foundation in Amsterdam was contacted by an elderly woman, identifying herself as Madame Rose Forcir, living in Saint-Honoré-les-Bains, Bourgogne, France. Madame Forcir stated that she had recently made a discovery which she believed could be of potential interest to the Foundation, but she refused to disclose the nature of her "treasure" until she could speak directly to someone with authority.

These inquiries are not uncommon, and within a few weeks, the associate director of the Foundation, Dr. Julius Oosterkamp, the renowned scholar and author of the recent best-selling book, *Van Gogh: The Man and His Mysteries*, returned her telephone call. During this conversation, Madame Forcir described

how workmen digging up her garden to install a pond had unearthed two dozen or so glass jelly jars and other assorted bottles, all sealed with wax, containing family documents, clippings from local and Resistance newspapers dating from WWII, and correspondence.

Among the findings was a packet of letters written by Madame Forcir's grandmother, Emma du Jardin, while she was a resident of the mental asylum in Saint-Rémy-de-Provence. She had reason to believe that the Vincent referred to in her grandmother's letters was the artist, Vincent van Gogh, as he was a patient at St. Paul's Hospital during the same time period as her grandmother's confinement there.

The following February, when Dr. Oosterkamp attended a conference in Paris, he arranged a visit with Madame Forcir to review the letters and to determine if her collection warranted further study by the Foundation's team of experts.

The letters, thirteen in all, are reprinted here, in their entirety, without commentary. While the rigorous authentication process

has not yet been completed nor have the facts contained herein been thoroughly investigated and verified according to our standard custom and practice, Dr. Oosterkamp believes this correspondence merits special and prompt consideration. His initial impressions and an account of his meeting with Madame Forcir immediately follow these letters.

St. Paul-de-Mausole
St-Rémy-de-Provence
8 mai 1889

My dear sister, please forgive the tremble of my hand if my writing is hardly legible. I try to steady myself by holding onto something solid, but this poor pen was not made to be an anchor. Still, I grab hold of it as if it were made of iron, as if it could hold me here, with you, safe from sleep. I fear I am slipping away again, and I beg you to come quickly, as soon as arrangements can be made. Please say nothing to Edouard just yet. I would not wish to trouble him with additional worries, especially since the doctor has recently sent him such a favorable report of my progress.

I have had another dream. No, this one was not terrifying, nothing resembling the horrific dreams of my dear Camille, when I awoke screaming with dread and fear, with my heart racing faster than my bare feet could carry me

across the cold tiles to the nursery where she slept. I dare not dwell on those dark nights this evening or surely I shall disappear alto-gether into black despair. Instead, I will hold my pen firmly and describe the dream I had this afternoon. It seemed quite ordinary at first.

This morning the good Doctor Peyron invited me to dine with him and his guests. A distinct privilege, he reminded me, because my disposition seems to have improved remarkably during my short stay here. My speedy recovery confirms his view that my dementia is not an affliction of my nature but wrought temporarily by tragic circumstances, the same sort of malady as might befall any young mother whose seemingly healthy baby dies unexpectedly for no apparent reason. Of my night terrors preceding Camille's death, he dismisses them outright, attributing them to the typical anxieties of a sensitive new mother. That I had the awful dreams and then she died is, in Dr. Peyron's opinion, like Edouard's, nothing more than unfortunate coincidence that, without doubt, contributed

to my crazy inconsolable grief, but for which I should feel no responsibility or guilt.

I am young and physically fit, and there is no reason, he believes, that I shouldn't have as many more babies as I desire. For weeks, my heart has resisted the judgment of this learned man of science, just as my head has resented and rejected the pious nods of nuns who try to comfort me with prayers and Scripture. What could they know of such sorrow, those shriveled old women who have never felt life quickening inside their own bellies or thrilled to an infant nursing at their breasts? I was just beginning to come halfway round to the doctor's way of thinking, but this afternoon I have had another dream which makes my body shake uncontrollably and perplexes me to the very edge of my wits.

It was a wonderfully long and pleasant midday dinner, much like those familiar to us in other, happier times, with Dr. Peyron's friends visiting from Paris. The food was delicious and well prepared, unlike too many of my meals here. A robust *Nuits-St-Georges*

complemented exquisitely the roasted pheasant, new potatoes, and white asparagus.

The conversation was equally dazzling. I felt perfectly at ease. How fervently I wished you were here to enjoy the lively talk of literature, theatre and the opera. But most especially marvelous, we were regaled with an account of the opening of the *Exposition Universelle*! The Braudels were disappointed, naturally, to see so few of the exhibits because of the crowds. Madame Braudel almost fainted three times in the veritable crush of humanity. I asked, "Was it as jam-packed as the exposition opening in '78?"

"The streets and boulevards and pavements were as congested as," M. Braudel paused and leaned toward me, "as the day of Hugo's funeral." He laughed when I gasped. "*Vraiment*," he said, with a nod, which seemed to indicate his complete satisfaction at surprising me. And then, *la pièce de résistance*, Madame Braudel described in rapturous terms Eiffel's *Tour en fer* blazing with electric lights, the beacon at the tip flashing blue, then white, then red, the cannon from the

top firing off to signal the day's closing, and no less than three locations of spectacular fireworks to end the evening. Oh, Dominique, it is almost too splendid to imagine! I can't wait to see it for myself. In the meantime, your eyes must be my eyes so please observe everything with special care and attention. I want details!

It came time for the Braudels to catch their train. I should have enjoyed a stroll about the terraced gardens—I needed to be cheered by the massive lilac bushes in full and gorgeous bloom—but it was uncharacteristically cold for May, and a sinister grey drizzle clung to the air, dampening my spirits. Indeed, the weather rather fit my mood. After the charming warmth and gaiety at dinner, the day had turned suddenly somber. I tried to recollect my dancing delight when the *avenue de l'Opéra* was first lit with electric lamps but my mind kept wandering back to last summer, to the *Quatorze Juillet* fireworks at Eiffel's unfinished *Tour* when my spirited baby kicked inside me with each loud boom.

Perhaps it was the sturdy wine which brought slumber upon me unawares. I dreamt that I was in St-Honoré-les-Bains, seeking a room at an inn. It was a perfectly natural extension of the conversation I had this morning with Dr. Peyron. He has suggested to Edouard that instead of coming directly home when I leave the hospital, it would be beneficial if I should take a cure for a few more weeks as a gradual transition back to my normal life. You know how highly Dr. Peyron and the nuns value hydrotherapy. He has suggested Baden-Baden or Vichy, but there I was, in my dream, at St-Honoré.

The concierge, a large, stern lady, showed me the only room available. It was small, windowless, sparsely furnished, and smelled of rotting apples. To be polite, I said I would consider it, but I had no intention of taking the shabby accommodation. I returned the next morning though, having decided that I would take the room after all. I was, actually, quite eager to move in straight away. The concierge, with the thick arms of a washerwoman, gestured to a red-haired, freckled-face man

sitting on a bench at a long table. "The room has just been taken by that gentleman," she announced, with no hint of regret or apology in her voice or demeanor.

He did not look to be a gentleman at all. He wore a crumpled jacket, and on his feet overly-worn boots, caked with mud. Beside him, on the bench, a wide-brimmed yellow hat, dripping wet. I approached him and spoke to him in French. He looked puzzled and I spoke to him, then, a little louder, in English. He acted as if he did not hear or understand me, and he turned his head away. I noticed, then, his mutilated ear lobe, but I knew he understood me perfectly well. He was exceptionally ill-mannered for no discernible reason.

I was about to confront him for his boorish behavior when I awoke to rapping on my door. Supper was ready. I washed my face and straightened my hair. I was not hungry, but the doctor and nuns emphasize that following hospital routine is a sign of health and, as I am most anxious to leave this place, I adhere to the rules as sincerely as I am able.

I turned the second landing, just above the vestibule, when I stopped short. There, under the arch, standing below me and looking up in my direction, was the strange red-headed man in my dream! He was wearing exactly the same crumpled blue coat, his worn boots caked with mud, holding in his hands the same dripping straw hat which had rested next to him on the bench, now making a puddle of rain water on the hospital floor. For a fleeting moment, I felt an irresistible urge to hurl myself down the staircase to his feet, and I had to grab hold of the banister to catch myself. I might have stood there for all eternity if the doctor himself hadn't come up the steps and guided me down. "We have a new boarder staying with us, Madame du Jardin. Do not be afraid."

I was not so much afraid as absolutely astonished. To dream of a stranger before I had ever set eyes on him? The oddness of such an occurrence was so stupefying that I remember very little of supper. The room was suddenly overly-heated, and there was, around me, the passing of plates, the clatter of

spoons against china, and the cheerful chattering of Mesdames and Messieurs, asking questions of the newcomer and making comments as if they were pleasantly curious and civilized residents of a boarding house and not voluntary patients in a mental hospital. They were all at their best behavior. The poor man will not always find such congenial dining companions here. Madame Bondieu, with her grey hair newly streaked with henna, did not bare her breasts and sing her arias nor did Monsieur Morin shout, stamp his feet or wave his cane in a threatening manner when Colonel LeBrun gobbled down the last of the bread without first offering it to the others.

I could not keep my eyes from the stranger, a Dutchman, Vincent, as Dr. Peyron introduced him, and he returned my forward gaze with intense blue-green eyes, brilliantly keen with understanding, even as he casually answered questions from the inquisitive, with scarcely a glance or a nod in their direction. He had the strong, rough hands of a peasant and a kind smile. He spoke to the others gently, in a deep voice, and with great

patience. Did I say, finally, "Please excuse the rudeness of my stare, Monsieur, but I had a dream of you before your arrival"? Or, do I only imagine that I spoke? Were my words as bold as my eyes? I cannot remember. Dominique, I cannot remember such a simple thing that happened just a few hours ago, and the inexplicable loss of my memory, too, is most distressing.

From down the hall tonight there is the constant wailing of Mademoiselle Subileau. It hurts my ears to hear her pain. I am not familiar with her particular predicament. Except for a spattering of freckles under each eye, she is a ghostly pale young woman, timid, as thin as a hatpin. She rocks continually with her eyes closed and talks softly to herself. But tonight, echoing through the walls, are wretched animal sounds such as those which might be heard in the depths of an African jungle when a helpless creature is slowly being torn apart by a ferocious beast. Perhaps I made those very same tortured noises when I was first brought here. And tonight. Tonight, how easily I could join

her in a chorus of anguish! Misery is a most terrible intimacy.

Please come quickly, Dominique. I need the serenity of your tender smile and your hopeful reassurances to restore my balance. On his visits, Edouard has found the *Hôtel du Cheval Blanc* clean and comfortable. And, kindly, bring more books. I have almost finished those you so thoughtfully sent along with Edouard last month. How grateful I have been to occupy my quiet hours with literature. It keeps my mind from idly wandering off into hopeless despair. I must resist that easy temptation if I am to get well enough to leave this place soon. And, too, could you please find a book with blank pages? Sister Epiphany has suggested that I keep a journal of my days here. It helps to pour the pain onto paper, she has told me.

I have not received a letter from Edouard for almost two weeks. I thought for certain that the doctor's last cheerful report would please him greatly, and I eagerly awaited an encouraging note from him by return mail. I hope it is his work which occupies his time

and attention, and not grief for our precious Camille or concern about me. Please watch that my dear husband does not exhaust himself with stocks and bonds and numbers, and convey to him my abiding love and deepest heart-felt longing.

I am calmer now, as I have held you close to my heart as I wrote to you. Please make haste. I remain your distressed but most devoted little sister, Emma.

P. S. Please respond in English, Dominique. I believe it lends more privacy to our communications.

St. Paul-de-Mausole
St-Rémy-de-Provence
16 mai 1889

Dear Dominique, It is a lovely summer afternoon, and I am sitting in the shade of a butterfly tree, enjoying a breeze as light and sweet as lilies-of-the-valley. This little Eden is a veritable feast for the senses. The sun is shining and the garden is gloriously ariot with exquisite flowers of all shapes and sizes, and buds, too, promising what will come. The colors and the fragrances are wonderfully intoxicating. Almost beautiful enough to eat!

I have just finished making an entry in the beautiful little journal which you gave me, and now I write to you. This silver traveling ink casket is as useful as it is elegant. What an inspired and timely purchase! I am so grateful that you have given me the means to enjoy the luxury of this garden while I write.

The good Chief Warder Trabuc has given me permission to bring flowers back to my room, and I have been sitting here trying to choose among them. No easy task, I assure you. It would be simpler, and greatly preferable, to sleep in this beautiful space, under the moon and stars, amidst the roses, irises, marigolds, feverfew, periwinkles and clematis, instead of being locked away at night in my small room, where I imagine the odor of aged Augustinians wasting away with prayers and fasting. I find myself curiously content here in this wild part of the garden, with its pines, tall grass, and thick undergrowth of ivy, where I can look down upon the lower terrace of well-tended flowers and trimmed hedges, with always a few cats sunning themselves or stalking an unsuspecting rodent. Perhaps the dark days of my long winter are over at last.

How grateful I am to you, dear sister, for your hurried and timely visit to St-Rémy. Yes, I know well how thoroughly shocking the hospital and its patients must have been on your first visit. You remarked then, half in jest, I think, that we should have accepted cousin

Georges' invitation to attend the Madwomen's Ball at Saltpêtrière when we had the opportunity. Would you truly have been prepared though? In my earlier letters, I tried to describe faithfully some of the bizarre and often frightening behaviors of the patients here, or "boarders" as we are called. The sudden outbursts of temper, the shouting of obscenities, the talking in strange tongues, the wild eyes, demented visions, exhibitionism, and other assorted odd and freakish mannerisms. It must be one thing to read of such peculiarities, and quite another to see them for yourself—without an orchestra and the festive atmosphere of a costume party. I apologize for neglecting to adequately warn you in advance that you would be subjected to such menacing rawness of humanity. My only feeble excuse is that I was so distraught when I wrote asking you to come that I did not think for one moment of your discomfort, only my own pressing need for your solace. Please forgive my selfishness.

Before you came, I should have recounted some of Dr. Peyron's instructions conveyed

during my first weeks here. He said to me, "You witness the abnormal, Madame du Jardin. One cannot help seeing it. Hearing it. Smelling it. Admittedly, it is not difficult to observe a wide range of disturbing eccentricities, all of which are, most probably, unfamiliar to you. They are everywhere, and some must be extremely disconcerting to a newcomer. Let me ease your mind. I guarantee that our violent and potentially dangerous residents, the Incurables, are kept safely away in another wing of the hospital."

How relieved I was to receive his reassurances! Dr. Peyron continued, "We discourage our boarders from asking personal questions of each other that relate to their past and the conditions which may have precipitated their voluntary confinement here. We want them to reveal themselves as they feel comfortable, without creating an atmosphere of interrogation and mistrust. I do urge you, however, to look for signs of normalcy among the guests whose company you keep. The normalcy is there, I assure you, Emma. Sometimes cleverly hidden."

I did not believe Dr. Peyron. But, I was willing to keep my eyes open. It is the only thing one can do in a place such as this, if merely to alert oneself to what may be lurking around the corner or behind a bush.

To my utter and absolute surprise, though, I did begin to see normal behaviors in the boarders. Sometimes it is fleeting, but it is there nonetheless. Mademoiselle Subileau stops rocking and lowers her head, blushing, when Madame Bondieu theatrically displays her ample bosom at dinner. Everyone claps when Madame finishes one of her arias, and we disagree whether Carmen's *Habanero* or Dalila's *Mon cœur s'ouvre à ta voix* is her best. I am convinced that she received some professional voice training when she was younger, and her Italian is impeccable, as far as I can discern. The tall and distinguished Monsieur Morin, who is almost as fastidious in his grooming as Edouard, seems genuinely mortified when he snorts, jerks abruptly and suddenly unleashes a string of obscenities. Colonel LeBrun generally stands when a lady enters the room. The rotund, one-eyed

roué is almost comical as he clicks his heels and makes a low bow to me. I am tempted to wipe the drool from his chin and then rub his bald head for good luck, but I do not want to encourage his favor. I suspect he is a Boulangiste, and I make a concerted effort to steer away all talk of politics at the dining table.

The Dutchman, Vincent, seems distinctly out of place here, as he alone appears to retain full custody of his senses, although he reeks of paint and turpentine, even when he is wearing his patched velvet coat at dinner. We have had many pleasant conversations about literature, as he is exceptionally well-read. He is even familiar with English and American novels; Dickens and Beecher Stowe are among his favorite authors. Although there are some times when he appears to feel uncomfortable in his own skin and there seems to be a hint of melancholy in his demeanor and he frequently complains about missing his pipe and tobacco, still, he is enthusiastically and obsessively devoted to making his art, preferring it to every other pursuit. Even eating

and sleeping, I do believe. With this wing of the hospital almost empty, he has been given a second room on the ground floor to use as a studio. Every day, weather permitting, he is outside, *en plein air*, either painting at his easel or bent over, totally absorbed in sketching. Curiously, while they may crowd around him to observe, no one speaks while he is at his work. It is as if everyone senses the importance of his labor, with reverence, and respects his need for quiet, even when they pay no heed to anyone else's request for silence.

That is to say, I have noticed how solicitous the boarders are of each other in many various circumstances. It is quite touching, actually, how these poor souls, even those with the flimsiest grasp of reality, seem to respond sympathetically to the needs, pains and confusions of others. I sense no falsity of tone. To the contrary, the boarders seem to live out the truth of their lives with whatever dignity and tranquility may be afforded to them. Indeed, there is a mysterious grace here,

to be sure, such as I have never before experienced in any church or fine Parisian salon.

Even as I describe some of the normal behaviors I have seen, I wonder if I am not myself succumbing to the influence of this place, with its apparent lack of inhibitions, propriety and pretensions. We have lived a very protected life, Dominique. More than we ever could have imagined, even in our dreams.

The other day, I watched a handsome young man, about my age, when he came to deliver groceries and other provisions. The rain was pounding down, as if the heavens had opened the floodgate of a celestial ocean. He worked slowly and methodically, unloading his cart with care, as if the sun was shining and the sky was a brilliant blue without a cloud on the horizon. He sang cheerful tunes while he carried the crates and sacks into the hospital. A strange feeling overwhelmed me. A light-headedness which was, at once, both calming and exhilarating. At the same time, I also had an incredible shift in perception, a sharp clarity of vision which brought some secret and urgent understanding of this

young man. As he was finishing his delivery, I reported the knowledge that had so suddenly come upon me. "You will have a long and very happy life," I told him.

He stopped and wiped the rain from his forehead with the back of his hand. "*Vous êtes une voyante?*" He seemed so serious. His brown eyes were so wide with wonder that, in another time and place, I might have playfully embraced him.

Moi? Une Voyante? The sincerity of his question made me laugh. Dominique, I laughed like an authentic lunatic, bent over, holding my sides and guffawing until tears rolled down my cheeks, all the while shaking my head and protesting. "No. No. I am not a seer. I am not clairvoyant."

Although he joined me in laughter, the poor boy probably believed me to be as demented as Madame Bondieu or Marguerite Subileau, which made me laugh even harder. He left the hospital still smiling and singing so I must not have frightened him too badly, and I am glad for that. Never before have I needed to worry if my natural behavior might

unintentionally scare another person. Do you think this new concern of mine is a sign of approaching health or diminished reasoning? It occurs to me just now that an asylum is not simply a place of refuge for those who suffer. It is also meant to protect Society from wretched, deluded people who might inflict harm to themselves or others.

Is it possible that I am *une voyante*, Dominique? I am not superstitious, as you know. I do not believe in miracles, magic or mysticism, and any other such silly things. Yet. For the life of me, I cannot deny the truth and significance of my own experiences, however unusual they may be. Do you remember the time I made Maman faint? When I told her she would find ants in the apricot jam, and then she did? We all laughed because it was so funny. But I was so young, barely able to speak yet, what did I know of ants? And what of the time I predicted that Sister Marie-Albertus would break her right arm, and it wasn't but a few days later that she fell?

You have assured me that my dreams are gifts, dear sister. But, I must ask: Of what

value is a gift if it is not used properly? If only I had paid stricter attention to my nightmares of Camille. If only.

My grief is greatly compounded because of Edouard's distinct lack of sympathy and understanding. These days his letters are vague and infrequent, and he has not come to visit for almost a month. I have great need for tender attention from my husband. The other day, when Mademoiselle Subileau's parents were visiting and Monsieur Morin was receiving his daughter and son-in-law, Vincent asked, "Why did your husband bring you down here, so far from Paris? There are many hospitals closer to your family. The one at Auteuil has been especially recommended to me." I did not have an answer. And Madame Bondieu, who seems to have as much familiarity with asylums and *maisons des santés* as she does with all the theatres of Europe, offered that she was once confined at Saint-Mandé, a clean and comfortable private establishment which is readily accessible from Paris by the Muette-Belleville omnibus, with a *correspondance* to Vincennes. "Hugo's

daughter was there with me a while ago," she confided. "The old man would not allow his own child to be kept under disreputable conditions, now would he?"

In March I was hardly in a condition to protest, or even question, Edouard's decision. Do you know the reasons why he chose this particular establishment, Dominique? Profound grief? Embarrassment at my condition? Fear for his own safety? Surely he must have discussed my pending hospitalization with you and Henri before he took me away.

I am feeling rather abandoned and bereft and bewildered. I came here voluntarily, after all, and Dr. Peyron believes it is only time, and not medical attention, which will ease my pain. On at least three occasions, he has suggested to Edouard that I am nearing the end of my stay, and that Edouard should make arrangements for me to go to Vichy or another mineral spring. I fear it is almost too late to secure reservations at a comfortable and clean establishment for this summer. I cannot comprehend Edouard's hesitation. Yes, your little sister cannot see the heart of

her own dear husband whom she has known and loved since childhood. If I am *une vrai voyante*, I am a very bad one, indeed!

Please talk to him, Dominique. Or perhaps, it would be better if Henri spoke to him, as Edouard might be more candid with his brother-in-law. Does Edouard fear that I may become pregnant too soon? Or that I shall break apart again with little provocation? Has he lost all affection for me? Has he returned to gambling?

No. It is too beautiful an afternoon to distress myself with marital matters. Perhaps I am silly and impatient, as Edouard claims. I will inhale the calming scent of lavender as I sit here, and I will write once more to Edouard, asking that he explain himself so that I may support him as best I can. If I can survive the death of my sweet, chubby-cheeked baby, then surely I can withstand whatever he might need to tell me.

As for you, you have written little of the wonders of the Exposition. I implore you to please set aside your prejudices. If you must, try to forget that the *Exposition* is a

centenary celebration of the Revolution. You must not sulk like Queen Victoria and the rest of Europe's dwindling royalty. You would be depriving yourself of enjoying the marvels of progress, science and industry and art. The Telephone Pavilion, with telephones hooked up to listen to music played at the *Opéra*? Can it be true? And the *Esplanade des Invalides*, with its wonders from *les pays chauds*, especially the gamelan music from Indonesia and the erotic Egyptian *danse du ventre*. I have read the rave reviews of all this and the Wild West Show in several different papers. For my sake, please encourage Henri to take Gaston to the arena at Neuilly. Can you imagine his wondrous little-boy excitement at seeing real live cowboys and Indian Chiefs in war paint? And there is a woman sharpshooter who can shoot a hole through a ten-sous coin while galloping on her horse. Perhaps we French ladies should take lessons from our American sister.

In the meantime, please send more books. I am particularly interested in reading *Uncle Tom's Cabin* by Harriet Beecher Stowe.

Vincent has mentioned its merit on more than one occasion. Also, on the second shelf of my library, near the window, is a thin little book with a worn purple leather binding, *Sonnets from the Portuguese*. Please send it along too, with more stationery, ink, stamps, and decks of playing cards. Madame and the Colonel are both incorrigible cheats, and by the end of an evening of manile or whist, there is scarcely a full deck to be found anywhere in the hospital.

I send you my love, dear sister, and I eagerly await your letters and packages. Kisses to my little niece and nephew, and warmest regards to Henri. Perhaps he can accompany you on your next visit. He is able to make me laugh in spite of myself.

As always, affectionately, your sister Emma.

P. S. Some pretty scented soaps would be wonderfully welcome, if it is not too much trouble. Madame Bondieu uses lemon soaps to great advantage. She recommends that a rosemary soap might suit me well as it lifts one's spirits.

St. Paul-de-Mausole
St-Rémy-de-Provence
16 juin 1889

My dear Dominique, Thank you for your telegram of a fortnight ago. It made me feel as if I am not quite so alone in this world. I trust you received my speedy return telegram, reassuring you and Henri that my health had suffered only a minor setback, and there was no need for you to drop everything and rush down to Provence again.

I promised that I would share the anniversary episode at a later time though I am certain that Edouard has already described to you, in lurid detail, the events that transpired here which precipitated his rude and hasty departure. I admit that I was selfish and petulant. Perhaps, too, my behavior was not as judicious as he would have preferred, but I was not irrational nor was I seized by erotomania, even if I may have lacked the

modesty befitting a lady. Is a wife's open and honest desire for her husband such a terrible and inconvenient burden? I have tried to explain these intimate concerns in more than a dozen letters to Edouard, and I've begged his pardon a hundred times for my ambitious overtures. Half the letters I've torn up before I sealed the envelope, but the other half remain unanswered, like so many famished orphans who cry out for sustenance, but receive no nourishment.

You know well how happy I was when Edouard sent word that he would be coming to celebrate our wedding anniversary—and I thank you for sending my azure Worth ensemble so promptly, and for including a hat and a pair of gloves which I had neglected to mention. Madame Bondieu confessed that she was a woman of the theater and kindly offered to arrange my hair for the occasion. She is exceptionally clever and efficient about such things. When I worried that I might lose one of her pearl and diamond hair combs, she waved off my concerns with a chuckle. "*Mignonne*," she said, "It is nothing. I've lost

more cherished lovers than valuable combs, and unfortunately combs are far easier to replace."

Dr. Peyron planned a special evening dinner in his residence, and invited a doctor, an attorney and their wives to the festivities. In the early morning of his scheduled visit I was in the garden, gathering blossoms for a centerpiece at Peyron's table. Marguerite Subileau did not speak, but she followed along after me, holding the basket of flowers as I clipped stems. In short, I was blissfully busy and as excited and eager to be with my husband as I was on our wedding night. For three whole days, I had even allowed myself to hope that we would be returning to Paris together.

I waited in the parlor for his arrival, trying to read from *Sonnets from the Portuguese* while glancing at the clock every other minute. Until, at last, with the chiming of the hour, my eyes saw: *The face of all the world is changed, I think, Since first I heard the footsteps*—and Edouard stood in the doorway, smiling. He opened his arms and I ran to be gathered up and embraced.

I think of that joyous moment now as if it does not belong to me.

As I neared him, I stumbled over his portmanteau. He caught me before I fell, and we both laughed at my clumsiness as we made our way to the settee. "Wait! Wait!" He playfully discouraged my hug. "First things first, little wife. I have a present for you!"

Edouard opened his bag and I caught a glimpse of the familiar red box. *Bébé Jumeau.* My heart stopped cold. I could feel the blood draining from my face and my stomach tightened in paroxysms of nausea. I took a deep breath to calm myself, and then another deep breath, and another. I was confused, too, by my body's sudden and violent reactions when just a moment before I had been so happy.

Last year you persuaded me that I should not have been upset when Edouard gave me a doll for the first anniversary of our marriage. "You are pregnant, Emma," you said. "Your husband is honoring your motherhood."

"With a replica of a doll he gave me for my tenth birthday? But I am his wife now. It seems bizarre."

As I wept, you convinced me six different ways that I was being foolish for objecting so strenuously to his gift when it was, in actuality, a sentimental reflection of his devotion. "Perhaps too mawkish for your taste, but I assure you that most wives would envy such a sincere and romantic gesture from their husbands," you said. Then you made me smile. You muttered, "I have never understood why you adored that doll anyway. Her bilious green velvet dress always gave me gas."

I answered, "I loved that doll when I was a child because Edouard gave her to me."

I recalled last year's conversation as Edouard lifted the box from his portmanteau and set it on my knees. He seemed oblivious to my distress though we sat close and my whole body was trembling of its own accord. He lifted the lid and impatiently parted the layers of tissue paper so that I could admire his present.

The *Bébé Jumeau* before me, a doll with curls the color of mine, was wearing a miniature of my own dusty rose satin dress, down to the lace on the collar and sleeves

and the three tiny pearl buttons in the front! Yes, Dominique, that very same dress I wore when Edouard and Aunt Sylvie took us to the garden of the *Trocadéro* to see the giant head of *Liberté éclairante le monde* before she was sent off to the United States. The very same dress I wore when Edouard took me up in the hot-air balloon for my eleventh birthday. The same dress you attacked with scissors because you were furious that you had not been invited to join us for the balloon ride.

I did not trust my eyes. I leaned toward the box to study the doll more closely, and I vomited all over her. Then I fainted. When I awoke, I was in my bed, with Sister Epiphany applying a damp cloth to my forehead. I suddenly remembered that Edouard was coming and tried to rise, but she urged me to rest. Edouard had gone to the hotel and he would return in a few hours.

I was strolling in the garden when he arrived for the second time. He approached slowly, but I ran to him and grabbed his hand and led him to my lovely hidden Eden where I spend so many tranquil hours. When

I stroked his cheek and tried to kiss him, he pushed me away, and when I persisted, he stood up. He declared that public displays of affection were unseemly, and that I was behaving as a *grisette* angling for a profitable alliance on the terrace of *Mabille's*. Yes, he said exactly that, and I should have slapped his face for the vulgarity of his characterization, but I did not.

I informed him that here at St. Paul's I had observed patients fondling themselves on numerous occasions, and surely a woman kissing her own husband in the privacy of this garden was no great sin or egregious breach of etiquette. When I began crying for want of his lips and some artful caresses, Edouard accused me of becoming unreasonable and hysterical. He suggested that Dr. Peyron should administer a steep dose of potassium bromide to sedate me. He seemed unruffled by my anxious pleas. His voice was as cold and impersonal as if he were ordering a carriage to be brought to the front door.

I was not hysterical, but I was deeply offended. Perhaps it was the pretty doll

wearing my favorite frock that pricked open a stream of pleasant childhood occasions when I was assured of Edouard's complete and unwavering affection. "How often did you beg me to come sit on your knees when we were in the Bois de Boulogne or at the Tuileries?

"Countless times, with my nurse and my sister and all of Paris to view your unhurried hand move slowly to smooth my dress or sharpen the pleats of my skirt. When you buried your face in my curls, I could feel your hot breath on my neck as I watched a puppet show or waved to Dominique on the carousel. You whispered sweet words in my ear while your fingers boldly and deliberately rubbed the fabric of my dress hard against my quivering skin. You once took great pride in calling yourself the Master of my blushes."

My words gushed forth without thought or effort as I enumerated our history of special encounters before I wore long skirts and his persistent petting became more circumspect. "Remember when I was older, in the darkened theater, how you used to tease me, whispering naughty bits of Baudelaire to distract me from

the stage? How you kept my hand pressed to your lap? Such liberties I allowed you!" I was positively giddy with pleasant memories, but when I opened my eyes, Edouard's dark eyes were staring back at me with all the savagery of an attacking Hun. I have never witnessed such a look of profound and absolute disgust, combined with what seemed to be a transparent willingness to kill. If I had been a man, I believe Edouard would have challenged me to duel on that very spot. Instead, he turned, without a word, and stomped away.

I followed after him though my footsteps were no match to his long strides. "You won't kiss your wanting wife? Shall I sit on your knees then in a public square?" I collapsed on a bench and cried. I made no effort to stifle my tears.

Most emphatically, I was not hysterical. But I was grievously injured by Edouard's rejection. It was the second anniversary of our marriage, and we should have been celebrating with long tight embraces and kisses galore. The place of our tryst did not matter to me. I am lonely here, Dominique. I yearn

for some human touch other than the merciless hands of the sisters forcing me into a cold bath or Colonel LeBrun's fat fingers fumbling for my knee at breakfast, lunch and dinner.

Madame Bondieu came and sat next to me. For a long time, she silently endured my weeping. Then she commenced with a repertoire of lullabies. She did not bellow in her usual stage voice; she sang softly. In French, German, Italian, and Spanish. When I was finally empty of tears, she patted my hand. "Be patient, dear," she whispered. "It is not unusual for the death of a child to interfere with pleasures of the flesh. I speak from my own experience."

"He gave me a doll, Madame, when I have a pressing need for only his touch. "

Madame slapped her knee and roared with laughter until she was wiping the tears from her cheeks with the hem of her dress, even as she begged my forgiveness for finding humor in my pain. "Men, even seasoned libertines, can be such clumsy creatures in affairs of the heart," she said. "To be perfectly frank, I myself have always preferred the awkward

ones. It means they have had little experience with other women, and have not yet perfected the skills of hypocrisy and deception."

I have spent these past two weeks contemplating the anniversary debacle. The only positive outcome that I can discern is that I have scarcely thought of my dear Camille nor do I hear her whimpering at night when I try to sleep. My focus has been almost exclusively on Edouard. I have also taken Madame Bondieu's remarks to heart. Ever since Papa first invited Edouard into our home, for more than half my life, I have regarded him as a charming and accomplished man of the world whose manners are as polished as his boots and whose morals are as pure and upright as his starched white collars. Perhaps I am too much still an adoring child and not yet a true wife who clearly sees her husband's imperfections, but who loves him anyway, in spite of himself. But then I think again: Can a long-standing member of the Jockey Club and a *boulevardier* truly be so simple regarding women?

I have also thought of you, Dominique, my darling sister, cherished friend, sturdy ally and trusted confidante. With Papa's death, followed so closely by Camille's passing, I fear I have placed an unfair burden on you. Instead of sending me reports of the happy adventures of Gaston and Louisa and good-natured complaints about Henri's misdeeds, I receive letters and telegrams filled with worry for your little sister's health and safety.

I have been so appreciative of your sympathetic attention and for every kindness you've extended that it distresses me to say what follows, but I must. I am absolutely appalled that you attended one of Dr. Charcot's elegant *soirées* with the express purpose of soliciting his learned opinion of my nervous condition. Yes, of course, I am quite aware that my mortification is trivial compared to the suffering you endured from Madame Charcot's gentle, but public, rebuke. Nevertheless, you knew well the etiquette of the evening when you accepted the invitation, and just one month ago, you sat beside me in Dr. Peyron's office when he advised that my prognosis is most

favorable, with only time and rest needed for a full recovery. Given that medical advice, why ever did you think that you needed to bother Doctor Charcot at a dinner party, especially in his own home surrounded by distinguished guests? Why not arrange for a private consultation at his office? Was it something that Edouard said about his visit that especially alarmed you? Even after you received my telegram? Did you consider for more than an instant that I might not want personal details of my tragedy to be bandied about among poets and politicians as a specimen of "hysteria" to be dissected like a diseased frog? It was cruel and thoughtless of you, Dominique, even though you might have had the noblest of intentions.

You cannot imagine how unsettling it is that the two people I love most in this world should both behave in strange ways that are so uncharacteristic of their customary deportment. I do not recognize my own dear husband since Camille's passing. And you, Dominique, the proper one, you have been always the stickler for following rules; I have

been the one forever dancing a little too close to the edge of polite society, as you have frequently reminded me for most of my life. I do not exempt myself from this confusion; I do not know the woman who broke apart when her sweet girl died nor the woman who is so easily reduced to tears upon the slightest provocation. Being so far away from home, from Paris, from all that is familiar and dear to me complicates the challenge of regaining a satisfactory mental balance.

In the late evening after I've exhausted myself trying to fathom the reasons for Edouard's continued reticence in communicating with me, I gaze at the postcard of Eiffel's *Tour* that you sent. Considering your unfavorable opinion of the "iron monstrosity desecrating the landscape," I am doubly touched, Dominique, that you overcame your loathing to favor me with such an inspiring reminder of Paris. How often you chided me for my fascination with its construction, and yet I could not take my eyes away from the marvel of its growth. If not for my collapse, I would have been among the spectators celebrating the

Tour's completion, just as I was there when the excavations first began and so many days in between. I think of Eiffel's brilliant design and the skill and the craftsmanship of the brave workmen, climbing up high into the air, making their rivets on their portable forges and straightaway hammering them into the iron, red glowing sparks flying everywhere. And, *voilà*, there it is at last, standing tall, graceful and as perfectly balanced as I aspire to be. For this postcard, I forgive you a little for your *contretemps chez Charcot*. But only just a little for now.

Dominique, instead of morose missives, please send chatty cheery news, as if I were away on an extended vacation. Have you been to the theater? Any concerts? Have you taken Gaston to see the Wild West Show? Has Aunt Sylvie resolved her differences with cousin Georges? I have no doubt she will disinherit him if he does not return to his medical studies, but why not grant him a year of traveling as he has proposed? What is the harm? She complains that he is dull, but then she objects when he suggests a grand adventure

for himself. The poor man cannot win. Please use your influence to persuade Aunt Sylvie to let Georges traipse about the Far East. Surely he should be allowed some enjoyment before he begins carving cadavers.

It has taken me two whole days to write this difficult letter so I shall end with the happy thought of returning to Paris soon, Emma

St. Paul-de-Mausole
St-Rémy-de-Provence
12 juillet 1889

Dear Dominique, I have so much to write, I don't know where to begin. Yes, of course, I do. I trust that you and your family arrived safely at St. Mâlo, and I hope your journey was not too arduous with the little ones. Does Gaston still fear the water as much as he did last summer? How I regret that I am not there to hold his hand, as I have in years past, when he ventures into the sea, slowly, afraid to look into the water as if a fishy might jump out of the water and grab his nose or his pee-pee.

And then, how grateful I am for the stream of packages you sent before you departed for Brittany! The books, the stationery and stamps, the playing cards, soaps, what a bounty of goodies! The chocolates were a most delicious surprise which I shared with the other guests, though reluctantly, as I could

hardly bear to part with any of their sweet-
ness, especially the hazelnut creams! Thank
you for your kind and generous spirit, dear
sister. Yesterday I received the last package.
Some of my summer clothes, and hidden
among the folds, your letter and two hundred
francs, in the event I may need money of my
own while I am here.

So you have heard from Edouard and
know my sad news. I appreciate the stren-
uous appeals that both you and Henri have
made on my behalf, and I regret Edouard was
not more forthcoming with his reasons for
bringing me here, so far away, and now, for
keeping me in this institution too long. His
correspondence is brief and annoyingly all
business. To date, he has made no mention of
his anniversary visit nor has he acknowledged
my voluminous entreaties for understanding
and forgiveness. How can we resolve our dif-
ferences or effect reconciliation if he refuses
to discuss these matters? Instead, he writes
that, at present, he is overwhelmed by work.
And yet, it is almost August, Dominique, and
Paris will be empty. When I protest, he calls

me willful and petulant, which he did in his last letter. "Proving my point," he wrote, "that most certainly you are not yet stable enough to come home to me."

Though I have no evidence, I suspect that Edouard has made some foolish investments which jeopardize his position at the firm, and he is attempting to redeem himself with even riskier speculations. Or, perhaps, he is spending his Sundays at *Longchamps*, losing a fortune to the horses. It is convenient for his pride that I am not there to ask him uncomfortable questions or make what he would consider unreasonable demands on his time. Aunt Sylvie relates that he has not been to her Sunday dinner for more than three months. She complains that he is almost as bad as Georges in his flimsy excuses for not attending. "Between the two of them," she writes, "they don't possess an ounce of originality or imagination," punctuated by a long trail of exclamation points.

If I had been told four months ago that I would be staying here until September, I might have inflicted serious harm upon myself out

of sheer desperation for my plight. However, as it is summer, and most beautiful in this little garden paradise where I spend most of my days and evenings, I shall not challenge Edouard's decision just yet though I ache for him and my former life on *rue du Cherche-Midi.* It seems, by comparison to the hospital, a most luxurious existence which I never fully appreciated as I should have.

At least now, darkness does not come so soon. Though the burning sun and heavy heat are often unrelenting in their oppression, I remind myself that it is preferable to the dead cold of winter or the chill of spring. The meals have greatly improved, with an abundance of fresh fruits and vegetables being served. The sisters, not known for their culinary skills or creativity, have begun sprinkling flower petals in our green salads which adds a delicious festive element to our noonday dinners. I have fragrant flowers in my room which helps detract from the stench of mold and the urine-soaked hall outside my door. And, with your gift, I possess the funds to leave on my own accord if it becomes necessary.

Money is freedom, and your thoughtfulness is highly valued. I sorely hope that it will not come to that, but it is reassuring to know that I can take the train back to Paris for only twenty-five francs. Now, too, I am able to purchase my own books directly without troubling you to send them.

As to events here...each time I proudly congratulate myself for adjusting to this place, something happens, good or bad, to upset my mental harmony. If I had not suffered such a complete collapse of my faculties when Camille died, I might attribute these ups-and-downs to the ordinary fluctuations of everyday life. Now I use them to gauge the soundness of my mind, or lack thereof.

The strangest day, by far, was almost a week ago. It began just before sunrise when I awoke, suddenly startled out of a deep sleep by a sense of suffocation. In the hushed dimness from my bed, I saw nothing, heard nothing, felt nothing. But from my window, across the courtyard, there were lights ablazing and a flurry of activity. The sisters, in their black habits, seemed to be swarming everywhere,

silent except for the hurried rustling of their skirts which, through my ears, was as deafening as a thousand bats unfolding their wings at once. It wasn't long before others awakened and began yelling and banging on their doors, as if they, too, perceived something unusually grim was afoot.

At breakfast we learned that a patient had hung himself. Vincent wanted to know if the poor man had been cut down yet, and at any rate, he wanted to immediately sketch the room and even the defunct himself. He left the table in a terrific rush to get permission from the Warder Trabuc or Dr. Peyron. He is forever grumbling about his need for models although Madame Bondieu has cheerfully volunteered herself on more than one occasion. I cannot imagine having the fortitude to sit and sketch a stranger who has so recently passed into eternity. What devotion to his art he must possess!

Mademoiselle Subileau began whimpering, and rocking faster, wringing her hands. Madame Bondieu sang some awful dirge in German while Colonel LeBrun helped himself

to more boiled eggs, cheese and croissants. My own stomach was squeezed into knots and I felt a surge of tears welling up inside my breast. Monsieur Morin snorted and grunted, and pounded his fist on the table. He said, "We should not allow ourselves to become distressed. I do not think any of us knew the man, or had even set sight on him. Most probably he finds himself in a far happier and more peaceful place than we do."

Perhaps there was wisdom in his words, but I was not so easily comforted. The poor man died alone. Will his family be relieved or bereaved? Did he have friends who loved him? Was he cut down before dying so that he could receive Extreme Unction before passing? Too many questions without answers plagued my mind.

Throughout the morning, I was further distracted from writing in my journal by the cacophony of disturbing noises coming from the dangerous Incurables wing across the courtyard. I went to the garden to read, but the noises continued. Some shrieks, I recognized, as surely being from patients getting buckets

of icy water poured over their heads while involuntarily submitting to the hospital's torturous bath regime. No doubt the industrious nuns were attempting to soothe the nerves of thrice their usual quota of victims.

Other screams pierced my ears with such excruciating inhuman pitches that I dare say they emanated from Hell itself. To mute the sounds, I covered my ears and burrowed my head as deeply among the flowers as possible, hoping their strong scent would render me senseless. Instead, to my horror, rising from the very bowels of earth, I heard a host of babies crying. I recited aloud, over and over, every poem and prayer I could remember, even as my tears spilled into the soil, but the sound of babies crying, the awful sound of crying babies, would not go away. It was then that my favorite cat, Luc, nestled close to me and purred. When I opened my eyes, I saw the dead bird he had dropped close to my face. What horror! I ran to my room, and I inadvertently left Vincent's copy of *Richard II* on the bench. It wasn't until late evening that I even remembered it.

How I needed a pleasant and diverting conversation at lunch! To my great disappointment, Vincent was not there. Dr. Peyron did not allow him to sketch the death scene nor the body, but he granted permission for Vincent to wander the field beyond the stone walls. Madame Bondieu saw him leave through the gate, loaded down with his easel, collapsible stool, canvas and palettes, accompanied by the male attendant Jean François, and heading toward the hills. Only Colonel LeBrun seemed to have an appetite. The rest of us ate little, in relative silence.

We finished with lunch in short time, all moving out of the dining room together. Marguerite Subileau broke away from the group, which was most unusual for her. She went directly into the cheerless drawing room and sat down at the piano, which was so very extraordinary that we paraded after her, *en masse.* You have seen Marguerite yourself. She is a mouse of a young woman whose most distinguishing feature is her ability to remain invisible for long stretches of time. Except for that one night of terrible wailing, I do not

think I have ever heard her utter aloud one whole coherent sentence to another person here, even the good doctor or the most compassionate nun, the Mother Superior, Sister Epiphany. She seems perfectly content to find a corner in which to rock and whisper to herself, and no one disturbs her peculiar revelry.

On that otherwise gruesome afternoon, the timid Marguerite sat down at the piano, leaned forward, and struck the first rousing chords of a Chopin *Polonaise* as if she were a veritable army unto herself. My God, Dominique, she might have brought down the walls of Jericho with the thunder of her fingers upon the keys! The strength of her vibrant playing shook the sturdy walls of this old monastery, and reverberated through me as if I were being lifted up to heaven on the wings of angels. The nuns came running, attendants, cooks and maids, and even Dr. Peyron rushed in to listen and watch. He stood, like the rest of us, transfixed, with a look of astonishment and pure pleasure.

Marguerite played another *Polonaise* and then another and another. Each one more

spirited, revolutionary and breathtaking than the last. She had no sheet music. It was as if her fingers were instinctively marching towards Warsaw of their own accord. I wanted to sing. I needed to dance. If Edouard had been there, I would have flung myself on him, consequences be damned. Yes, Dominique, the music was that overpowering. The room radiated with a glowing afternoon light. I felt my soul so full and flowing and flooded with love and joy and passion that I wanted to burst apart, like brilliant fireworks, showering sparkling stars down upon us all.

Marguerite played for almost two hours, seemingly oblivious to everything save the union of her love for Chopin's compositions with her passion for the piano, thereby creating her art: the laboring to bring into the world something real and alive and living, for there is no other description of the music she created—real and alive and living. What an unforgettably exquisite beautiful afternoon! And then she was done. When she stood up and turned from the piano, she was pale and trembling, and looked about to faint so

startled was she to see how many of us were all crowded into the room and the foyer, clapping and weeping with joy.

It was Madame Bondieu, her tears still streaming, who helped Marguerite up to her room while we remained standing, stunned and pleasantly reeling with the magic of melody swirling in our heads and pounding in our hearts. As she crossed the threshold, she turned and looked back upon us. She smiled sweetly, as if she knew how thoroughly she had soothed our morning agitations.

How sorry I was that Vincent was not there to share the ecstatic music. He, alone, I know, would have intimately understood the making of Marguerite's art. I hoped he was near enough to enjoy the music she was making, but he heard nothing. A pity that. The exhilarating impromptu concert had a profound healing effect upon all of us who heard it. An hour of Marguerite's music is worth one hundred hours of hydrotherapy! Supper that night was more like a celebration than a funeral. I was led to marvel at our fickle adaptability. How easily we were

transported from morning gloom to afternoon bloom. And by the mouse Subileau!

Later that night, when I could not sleep, I was compelled to wonder about the nature of passion and art. We, you and I, have attended many concerts, Dominique, and I can vouch that never have we experienced such an ecstatic performance as the one I heard that afternoon. Why should this be? Is it because we are so starved for any sort of diversion here? I do not think so. Except for the lack of my husband's affection and the comfort of your company these past months, I have felt little material deprivation, although this is certainly a more austere environment than that to which I am accustomed.

While we may have heard pianists whose technical skills compare favorably to Marguerite's, I do not think there is a musician alive whose passion surpasses hers. I think of Vincent's hungry eyes, how they always seem to be devouring a scene and composing it into a picture, whether he is regarding Mont Gaussier in the distance or a bowl of beans on the table in front of him.

The same may be said for Madame Bondieu and her singing.

Is passion a prelude to insanity? Are we prisoners to our passions? Can passion be tamed, as they try to do here with icy baths? Would art lose its power if passion were tamed? Or, does our passion and ardor redeem and transform us and our art?

I am reminded of Sister Epiphany, the Mother Superior and the gentlest of the nuns here. She knew her calling to the Franciscan order when she was but nine years old. Imagine such comprehension at that early age! Her devotion to God and to the teachings of St. Francis, her compassion, her art, is apparent in everything she says and does, unlike many of the nuns here, and there is no hint of madness in her manner.

I wanted to puzzle out these ideas with Vincent, but he left for Arles early the next day. He was eager to see friends and to finish business he had there—to pick up some canvases and to make arrangements for furniture he had left in storage. While he was gone, I realized that a substantial measure of what

little happiness I find here has been derived from Vincent's company and friendship.

Despite the vast differences in our backgrounds, we do share some consoling interests which have sustained me these past few months. Most definitely, Papa would not have approved his political views, but he would have greatly respected Vincent's ambition and his single-minded dedication to his work. Our mutual love of literature is a subject of delightful exchanges which I fervently welcome at every opportunity. Voltaire, Hugo, Zola, Dickens, Eliot. We could talk for hours and hours if Vincent were not so keen to get back to his paints. And this, too: as a young adult, he spent some years in England, and he speaks English fluently, even idioms, so I am able to practice my conversation and pronunciation skills with him, as I practice my writing skills with you.

You ask if Vincent has talent, and how am I ever to answer such a question? I am not like the other boarders, silently crowding around his easel when he is outside, looking over his shoulder to observe how the movements of

his brush will translate onto the canvas. I have seen most of his work only at a distance, and it does not resemble the work of your favorites, David and Ingres. His studio is on the ground floor and I pass it often. Although I have been curious to peek inside, I have waited for an invitation, which has not yet been extended.

On the other hand, judging his art may be like trying to measure the circumference of a ball with a straight ruler. He has a rather humble opinion of himself, but he aspires to greatness and applies himself most diligently. Wouldn't Papa have declared that a recipe for success? And doesn't Zola say, "When love and skill work together, expect a masterpiece"? I do know, with absolute certainty, that Vincent has the vision of an artist, which is to say, a distinctly unique way of looking at the world. Truly most different from ours.

From the very beginning of our acquaintance, I noticed that he recalls scenes from novels strictly in terms of the visual images they evoke whereas I remember scenes in terms of the feelings they produce in me. We

have discussed how it must be the artist in him and the woman in me which accounts for our differences of memory and opinion of certain passages.

Since then, I have also had occasions to walk with him about the park and gardens of the hospital. What wondrous adventures, Dominique! Vincent's intense eyes seem to be everywhere at once! His eyes! Their color is as inconstant and unpredictable as the sea. Now blue, now green. I marvel at their variability as much as I marvel at what they behold. He calls me to observe the fickle colors of the sun and sky and clouds, then sweeps his arm across the horizon, drawing my attention to the sharp lines of Alpilles rising in the distance and the flaming shapes of the cypresses and the twisting olive trees. He directs me to notice the very greenness of the ivy at our feet, growing on the gnarled roots of trees. He patiently points out the greatest and the smallest of details, most of which I might have overlooked if not for his expert guidance. With him, I always feel as if I am looking with new eyes at a new world! He is helping me

to see the nobility in Nature, as I have never appreciated it.

What endears Vincent to me, though, is his tender empathy for the depth and breadth of my grief. Yes, Dominique, you have been a great source of strength and consolation, for which I am deeply grateful and forever indebted to you. You have two beautiful and healthy children, and fortunately, you have never experienced the death of a baby. Vincent understands me in quite a different way. He grew up in the cold shadow of his mother's grief. He was, in fact, even named after his stillborn brother who was born exactly one year to the day of his own birth, which he feels placed a particular burden on him.

"For every pain," he told me, "there is a great purpose." Though I believe he was referring to his own suffering, I realize I must find the blessing in this breakdown of mine. This spring, I was entirely at grief's mercy, but gradually I will conquer it. I must conquer it, vanquish the ghost, so to speak, so that when I am ready to have other children, I shall be able to love and cherish them for themselves

alone, and not as replacements for the precious Camille whom was seized too soon. As Vincent reminds me, "Grief must not gather in our hearts like water in a swamp."

Perhaps I have been able to help Vincent, too, but in a more modest respect. One morning, a few days ago, when we were walking in the garden, he began talking about himself. It was most unusual for him to be so personal. Apparently he had received a letter that morning from his new sister-in-law. She is happily expecting a child and Vincent will be an uncle within the year. He confessed that he was feeling like an old man that day, though he is only thirty-six, just a year older than Edouard. He lamented that he will never find a wife suitable to his temperament, as his brother Theo has found, nor will he know the joy of his own children.

At first I laughed at his concerns, not believing him to be serious. But then, he frowned and visibly winced, and I quickly realized my mistake. How easy it was to relieve his troubled mind! I led him, then, to the stone bench under the pines and I

invited him sit down beside me. I related how
Edouard had waited until he was established
in his career as a stockbroker before he pro-
posed marriage, and just last year we began
a family. Young women, I told Vincent, are
very much attracted to older men who are
worldly and wise, who have learned compas-
sion and earned their joy from life experience.
I assured him that he should possess every
confidence that he will find a worthy partner
as soon as his heart is ready.

He was in a rather morose philosophical
mood and quoted a line he attributed to Jean
Richepin, you know, the poet whose volume
Chanson des gueux caused such a stir that he
was jailed for a month and fined 400 francs?
"L'Amour de l'art fait perdre l'amour vrai."

Then, I did laugh at him. I was moved to
lift his rough painting hand from his knee
and draw it to my cheek and then to my lips.
I kissed the fingers which hold his reed pens,
his chalks and brushes, as I might have kissed
Papa's hand when he seemed discouraged.

"Poor man," I whispered. I kissed each
finger freckled with specks of violet and yellow,

and smelling of turpentine. "How foolish! The love of art most absolutely does not mean the loss of true love. Quite simply, you must find a woman who loves art as truly as you do."

Since we have no secrets between us, Dominique, I will tell you frankly that when I kissed his fingers the second time, I was seized by a most pleasant dizziness. From turpentine fumes? I cannot say. I wondered if his moustache and beard smelled of turpentine too. And his neck, and the length and breadth of his bare chest, too. When I looked up at him, in that instant, I wanted to place his paint-streaked hand on my breast and I wanted to kiss him, deeply and without reserve. My body knew this before my mind understood. How strange it was, the longing. Vincent is hardly the sort to engage in flirtations, and neither am I.

"Our mutual friend Richepin insists that 'One may live without bread, but not without roses.' Now which is your art, monsieur— bread or roses? Or both?"

I made him laugh heartily, which is most rare and delightful to hear. He agreed that

Richepin was right, in spite of his Calvinist upbringing. "One cannot argue against roses, after all!" Did I tell you that Vincent once trained to be a preacher?

As we strolled back to the hospital, I wondered if he had ever danced. Or, did he deny himself the pleasure from religious conviction? I wondered what it would feel like dancing in his arms at a gala, and I imagined sitting beside him before a bonfire on the beach of a village after the boats have brought back their bounty.

"And arguing with you would be like arguing with a rose." He spoke softly as he walked behind me, as if I was not meant to hear him. But I did. Or did I? Was it my ears which were open, or my heart?

Enjoy your family holiday in Brittany, dear Dominique. In a matter of weeks, I shall be joining you back in Paris, whether by Edouard's decision or my own. What a pleasure it will be once again to see your kind and lovely face and shower kisses upon little Louisa and Gaston. I cannot believe your little genius is reading already! How many other

milestones have I missed? No, please do not tell me. I do not want to harbor bitterness towards Edouard for his judgment regarding my lengthy stay here.

What fun we shall soon have together! I have learned much about art from Vincent. We shall have a fine time at the Louvre, and exploring the shops of art dealers. Perhaps we shall even meet Vincent's brother Theo at Goupil's and buy some paintings! My eyes are more attuned now as to what we should be looking for, with regard to subject and perspective, color and composition. I have also come to believe that we have a solemn obligation to support artists, not just with our high praises but also with our heavy purses. Forget hats and gloves, shoes and brooches! We shall tell Edouard and Henri that we are making investments! Though our spending will be but a trifle compared to theirs, at least we can hang our investments on the walls and enjoy their beauty and complexity, and we shall feel the richer for it, I assure you.

Your sister, who misses you and yours with her whole heart, Emma

St. Paul-de-Mausole
St-Rémy-de-Provence
29 juillet 1889

My dear Dominique, I share this tremendous sadness with you. Within a few days of Vincent's return from Arles, he suffered a complete breakdown. It came as an unbelievably cruel shock since he seemed so healthy and competent, so passionate and productive in his work, so lucid in his ability to express himself, in conversation and his art.

I am devastated, and it is no exaggeration to report that his absence has had a deleterious effect upon our whole group, or "menagerie" as Vincent refers to us. If he, so apparently healthy and keen of mind, if he can succumb, then none of us are safe. He has been indisposed for more than ten days now, and we have been made to feel all the more vulnerable to the wild whims of illness.

We are as fragile as crystal in a stable of stallions. Monsieur Morin pounds the table, and sputters and stutters and swears so frequently that it is difficult to follow the meaning of anything he is trying to say. Colonel LeBrun clutches at himself continuously, sometimes with both hands, as if he suspects someone wants to steal his precious privates. Marguerite cut off her long brown braids, and styles her short hair in a mannish sort of way. Madame Bondieu does nothing to her hair these days. She wears it long and dirty and uncombed. When I gently hinted that she might be more attentive to her appearance, she snapped back, "My dear, only the sun disappears beautifully." She has also stopped singing altogether, as if she has lost her favorite audience. When I suggested she might entertain us one evening with a recital of her arias, she snarled and spat at me.

Last night, when we were outside playing *pétanque* after supper, we all observed Colonel LeBrun snatch up a cicada by its wings and pop it into his mouth as if it were a chocolate. It was a revolting sight, most

worthy of a stern reprimand, to see the colonel's cheeks twitch as if the poor creature was desperately trying to escape before being swallowed. Monsieur Morin threw one of the *boules* at him. Fortunately, the *boule* missed the colonel's head by centimeters, but now we are restricted from enjoying one of our few group pastimes.

I have not seen Vincent since his collapse. I am not allowed to see him. And, worse, I am able to glean only unsatisfying fragments of information as to his current state of health. It is most frustrating. No, it is Damnably Outrageous, to be restrained from seeing him and to have vital details withheld from me. For example, I do not know whether he is eating properly. Even when he appeared healthy, he seemed to have little appetite for food. At least when he joined us for meals, I was able to tease him into accepting a little more soup and another piece of bread or cheese. Now I do not know if he is eating at all.

The attendant Jean François tells me that at the onset of his collapse, Vincent was gathering up dirt and shoving it into his mouth.

Vincent kicked him in the groin when he tried to stop him. No one else witnessed this incident, as far as I have been able to determine. Colonel LeBrun reports that on the men's floor, he has heard Vincent yelling night and day, and it seems to him that Vincent is completely out of his mind and suffering from severe religious hallucinations. He also rants about seeing the tombstone of his dead brother, his namesake. It seems unlikely to me, and I cannot confirm the colonel's observations or his veracity. This separation from us cannot be good for Vincent's spirit, or ours.

I know now, with absolute certainty, that the dream I had of Vincent before his arrival connects me to him, as surely as Providence connects the wind to weather. I am thoroughly convinced that I should be with him through this terrible crisis, and I am left feeling utterly helpless. Almost as helpless and tormented as I was when I clasped Camille close to my heart while her young life was seized from this world.

The doctor, the attendants and the sisters, they have all assured me that Vincent's life

is not in jeopardy, but that is only a little comfort. I want to embrace him. I want to hold him close and hard. I want to give him the strength of life which surges through me. Just as our mighty moon can pull the tides of this earth's oceans, so I trust that I can pull Vincent out of sickness and back to health.

For expressing my concerns, the nuns punished me with three icy baths last week. On one occasion, Sister Loretta hissed into my ear, "Your heart is too easily made glad." On another occasion, she muttered, "Guard against your fondness, Emma. It is lustful." Then she pushed my head under water and held me down until I felt my lungs about to burst. I still have bruises on my shoulders. But brutality has done little to weaken my resolve. Such is the power of my faith and fortitude and determination that Vincent should be well and painting again, and that I shall assist in his recovery, come what may.

Edouard continues to frustrate me with silence. I did receive a letter from him the other day. He was leaving for London on business. He apologized for the brevity of his

message, as if he is just now noticing how curt and unsatisfying his communications have been, and he expressed regret for the necessity of leaving on such short notice without first visiting me. It is becoming increasingly difficult for me to interpret his behavior with lovingkindness, Dominique. How long can I continue to attribute his coolness to profound grief for the loss of Camille? Did he bring me here because he was truly concerned for my health and safety or because my tears and sorrowful spirit were a burden or an embarrassment to him? Is he punishing me for our baby's death? Or, desperately trying to forget it? All my wondering is in vain, of course. I cannot draw conclusions until I see him, and perhaps that is the very reason he stays away.

No, Dominique, I will not dwell on such dreadful and discouraging ideas. Instead, I will turn my mind toward more cheerful thoughts. I have not yet received any news from you since your arrival at St. Mâlo so I assume the best: you must be thoroughly enjoying happy and relaxing days with Henri and the children. I imagine you all at the

beach, with Louisa and Henri building castles in the sand, and Gaston walking along, swinging his bucket, bent over and searching for pretty shells. Were you able to engage a suitable cook this summer? Is the weather quite as beautiful as it has been in past years?

Tomorrow, early, I will be mailing this letter myself from St-Rémy! The kind doctor has given me permission to walk into the village with the nuns on their morning errands, as it is market day. Most assuredly, the exercise will do me good, and I may be able to wander among the stalls and into some shops to buy some ribbons or chocolates or books. The change of scenery will be beneficial too. Perhaps I shall even encounter my handsome delivery boy, and inquire if his life is as happy as I predicted it would be! How could it be otherwise?

I am eagerly awaiting a letter from you in these troubling times, affectionately, your sister Emma.

St. Paul-de-Mausole
St-Rémy-de-Provence
25 août 1889

Dear Dominique, I send this letter directly to Paris, assuming you will be home by the time it is delivered. I finally received your letter from St. Mâlo! You needn't have worried on my account, dear sister. Your good news did not disturb or sadden me in the least. Congratulations! What better way to celebrate a new year than with a new baby?!! I am glad to know that you are healthy and in excellent spirits. You must insist that Henri pamper you endlessly since that is exactly what I would do if I were in Paris. And, you must not even consider another trip to this awful place, do you understand? Have you chosen any names yet?

Please forgive me, Dominique. I did not intend to alarm you with the sentiments I expressed towards Vincent in my letters of

the 12th and 29th of July. Again, be tranquil! Most definitely I am not slipping into bovarysme. I thought this matter was resolved after the Charcot incident. Please refrain from listening to doctors who are unfamiliar with my circumstances, and yes, even those prominent alienists whom you have consulted in your kind-hearted solicitude for my welfare. You will only needlessly frighten yourself with unwarranted speculation. Of course I have concerns about Vincent's health and his treatment, as any caring friend would. He has had no visitors since his arrival here, as far as I have seen. No friends or family to whom the staff should be held accountable, face to face.

As to Sister Loretta's comment about my fondness for Vincent. . . She enjoys torturing the boarders, and she will say anything to justify her pleasure in inflicting pain. Her true calling, I do believe, is butchery. The slaughtering of helpless calves and lambs and rabbits. But then, as poor dumb animals, they could not fully appreciate her power. She practices her own particular brand of *schrecklichkeit*; half her pleasure derives from our

frightened and keen awareness of her dominance and our commensurate inability to minimize its painful effects.

Please concern yourself now with remaining calm and serene as your baby grows inside you, and enjoy the antics of Gaston and little Louisa. Surely they will miss your attentions when you must direct your care towards your newborn. Remember your own feelings when I was born? How you resorted, finally, to misbehaving and tantrums so that Maman would take notice of you? At least that is what you have related to me, and didn't we witness this very same reaction from Gaston when Louisa was born?

In your letter, you did not mention hearing from Edouard. I, myself, have only received two messages from him this month, and both were mailed from London. He seems quite pleased with himself; apparently he was orchestrating some merger which went well. Far better than he had anticipated. In a second letter, which I received just yesterday, he said he was looking forward to going down to Brighton for a few days of rest before he

returned to Paris. He did not provide a specific schedule, but I presume he should be back in Paris by the time you return.

Please visit him as soon as possible, Dominique. Or, more *à propos*, insist that he visit you. I am most anxious to know your impressions of his appearance and demeanor before he visits me here. His letters seem to lack the kind of warmth and yearning one might expect from a lonely husband, even the ones I received before his anniversary visit. But then, it is just as likely that I am overly sensitive to his preoccupation with the *Bourse* and boring business affairs. Oh, how I have learned to doubt myself since he brought me to this place.

Do you know that since the day Papa invited his new clerk to Sunday dinner and we were introduced to him, Edouard and I have never been apart this long? That was almost a dozen years ago, if you can believe it, when we were still schoolgirls. Remember how I blushed and giggled when he pulled my braid, and then he bowed and kissed my hand as if I were a grown woman? Could you

have imagined that day, as we feasted on duck and escargots, that little more than a decade later, both Papa and Maman would be gone, that you would be the mother of two children and that I would be married to our handsome visitor, but temporarily confined in an asylum? How droll life can be!

As to dear Vincent's health…it wasn't but a few days ago that he finally ventured from his little room. We were thrilled to have him back among us, but I was distressed that he was so haggard and anemic-looking. So thin, in fact, that I insisted to Dr. Peyron that Vincent should be fed some beef and wine, and I gave the doctor money to purchase it for him. The doctor should not be stingy when the health of his patients is at stake, but that is exactly what is said of him, and I believe it.

Vincent is much changed, and not just in appearance. He seems unusually sad and quite aloof, and he has not been out-side in fresh air for weeks. I thought some new paints would cheer him—he is always in need of more tubes of zinc whites, greens and blues—and I mentioned to the doctor

that I would order them myself from Tanguy's shop in Paris. The doctor would not countenance any such thing. Apparently, while he was ill, Vincent was sucking his paints from their tubes!

"In an effort to poison himself?" I asked.

The doctor shrugged and muttered, "Who can say? More likely than not. As a precaution, we have confiscated all his paints and equipment, and for the time being he is forbidden to work or enter his studio."

"How could you do that to him?" I demanded of the doctor. "Even when the *mistral* was strong enough to blow the ears off a donkey, as you people say down here, Vincent was outside, anchoring his easel with stones, and painting still."

The doctor looked down at the papers on his desk and seemed to be reading from one of them, not even discreetly. His apparent disinterest in our conversation infuriated me.

I banged my fist on his desk. "Dr. Peyron! Please pay attention. Since he has come to your establishment, Vincent has worked night and day at his art. Relentlessly. As if

the strength and pursuit of his passion would save him from every illness. No wonder he is despairing now. You must devise a way let him work in safety." Dr. Peyron nodded and waved me away without seeing me to the door.

I shall keep a close eye on the doctor. I sincerely hope that he recognized the authority in my voice. I have recently learned that his training and specialty is not mental maladies or emotional afflictions. Dr. Peyron is a retired eye doctor! If Vincent is not allowed back in his studio within the next few days, I shall write a letter to his brother Theo and insist that he be removed from this institution as quickly as possible. It is a matter of life and death, I believe. Yes, it is that serious. If it were otherwise, I would be on the train to Paris tomorrow. As it is, I need to be reassured that Vincent is well on his way to recovery before I can leave him to this place.

There is this, too: Tonight, Vincent excused himself from the table early. He ate little and talked less. "A soreness in my throat," he explained. But the whole time during the

meal, he seemed fidgety and most anxious to escape our company.

As soon as he was out of the room, unprovoked, Monsieur Morin grunted rapidly four or five times and slapped his knee, then yelled out, "Germs. Germs. Fuck you, Germs! Fuck you!"

His words seemed to enflame Madame Bondieu who rubbed her breasts against his arm and began singing to him, *sotto voce*, "My heart opens to your voice." Colonel LeBrun must have enjoyed her performance as he fondled himself with a disgusting gleeful vigor, and there was no attendant in the room to restrain him, as Jean François was escorting Vincent back to his room. It wasn't until Marguerite said, quite loudly and clearly, "Germs?" that the room went suddenly silent. Madame Bondieu sat up straight and the colonel abruptly dropped his hands into his lap. Marguerite looked directly across the table at Monsieur Morin and repeated her question, "Germs?"

It became like a game of riddles. With many questions and much patience, we

were finally able to decipher the meaning of Monsieur Morin's outburst. In his past life, Monsieur Morin was a professor of chemistry at the *École Normale Supérieure* when Dr. Pasteur was its Director of Scientific Studies. He worked with Dr. Pasteur in proving that it was a parasitic microbe, a germ, which was causing silkworms to die. Yes, Dominique, it is, in part, because of Monsieur Morin's research that the French silk industry thrives today. We owe him a special debt of gratitude.

It is Morin's theory that Vincent has come to believe that we can infect him with our derangements. Hence Vincent's newly acquired unwillingness to fraternize with us. While I do not believe that insanity is contagious by way of germs, few of us in this place are immune to its influence (even some of the nuns seemed crazed on occasion!). Vincent may be particularly vulnerable at this time, and he may fear us. He may fear that our bizarre behavior might precipitate a relapse in him.

"We must be especially kind and gentle towards him in all our interactions," I told

the group. "And, we must not scare him with too much attention, however much we may miss his company." Who knows if my words will have a calming effect upon the others. Or if our efforts to be more subdued will lessen Vincent's distaste for our company. We shall see.

It has been blistering hot here. Suffocating enough that we plead to be tortured with a bath. That reason alone should be sufficient to make you laugh! The good sisters do little to minimize our distress. What sadists they are! Subjecting us to icy baths when it is cold and withholding baths from us when water would be a welcome, almost necessary, relief. How grateful I am for the two tea gowns you sent among my summer clothes. I have taken to wearing them almost exclusively, with the sleeves taken off and no undergarments! I have lost weight and it is like wearing a wonderfully loose tent, with the air swirling between my legs as I walk. What glorious freedom!!

I have found a secret way to make myself more comfortable at night too. I am sleeping

outside! One evening, quite by accident, I was not in my room when Sister Epiphany locked my door. I went to the wild part of the garden and stretched out in the dense ivy. It was as comfortable as any mattress I have ever slept upon! After dark, the cicadas are quiet, and though I sometimes hear rustling in the grass, I imagine it is only a breeze. It is so earthy-smelling and tranquil out there, Dominique, and the sky is so immense. I fall asleep almost immediately, and sleep soundly with no disturbing dreams.

Since that first time, I have dared to sleep outside five more times. What harm in that? It is only a small liberty that I take for myself. There must be some advantage to being judged crazy! In most every other way I follow the foolish rules and hospital routines as obediently as an aspiring novice, though it is sometimes an effort to be docile about it. Maman would be pleased that I am finally learning a measure of patience.

Vincent has often marveled aloud at how different the Provençal sun is from the sun in Paris, London, Antwerp or Holland. Once, he

said to me, "The colors of the prism are veiled in the mists of the North." Since he mentioned it, and in such a lovely way too, I have seen this truth myself. The light here in the Midi is more penetrating than that in Paris; the colors more vivid, almost vibrating. I am reminded, too, of that trip we took to Amsterdam. Do you remember how the fog was so dense that we couldn't see our own hands in front of us? That day, the air was less like a veil and more like a shroud! Imagine growing up in the gray and gloomy Netherlands. Especially for an artist such as Vincent, who is particularly sensitive to the power and nuances of color. It must be very like those years we lived in London when we were children. We were as homesick for the sun as we were for France. Fortunately, the mist is not so heavy in Paris. Even so, it is brighter here than in Paris, the colors are deeper and richer.

It is also true, as I have discovered, that the Provençal night sky is different from that in Paris. When I lie down and spread myself into the ivy, I feel my body opening itself, every pore, as if I am as vast and limitless as

the whole universe. As if my body is naught but a crunchy shell the cicada leaves behind when its essence disappears into eternity. Heaven seems much closer to earth down here in Provence. Sometimes, in the darkness, I sense heaven so near that if only I could stretch my arms a tiny bit farther, I might be able to grab fistfuls of stars. What a fine gift that would make for my new little niece or nephew!

Again, congratulations for your truly wonderful news. I remain an eager aunt about to be thrice blessed, your loving sister, Emma.

P. S. I have spent almost fifty francs of the money you sent. Mostly on books, combs and ribbons. I have to wear my hair up, off my back and away from my neck, or I will surely cut it off as Marguerite did hers.

St. Paul-de-Mausole
St-Rémy-de-Provence
2 septembre 1889

Dear Dominique, You will, no doubt, know my news before this letter reaches you, as Edouard said he would be coming to see you first thing this morning. I write to reassure you that I am not upset. I am—I don't know what I am today—but I am not upset. Edouard was here yesterday. His visit came as a complete surprise to me, with no advance notice, although I suspect that he sent a telegram to Dr. Peyron before his train left Paris.

As I was coming down the corridor after Mass in the little hospital chapel, I looked up and saw Edouard standing with Dr. Peyron in the vestibule. To get to him, I think I pushed aside no fewer than four nuns who were strolling in front of me. It has been months since he has visited, and I was so happy,

Dominique, so delighted to see him, to hug him and to hold him close.

We left the hospital grounds through the iron gate and first wandered among the Antiquities at Glanum, immediately adjoining the hospital property. The *Arc de Triomphe* and the Mausoleum, the sisters have told me, date from the time of Caesar Augustus. I wondered if Vincent has painted the scene. He has never mentioned it, but the views of the ruins are certainly deserving of his consideration.

We started walking toward the village. It was a beautiful day. The most beautiful day. The sun was shining, but it was not too hot. Depending upon which direction I turned my head, lavender or rosemary perfumed the warm air. I was walking along the hawthorn hedges, under the shade of plane trees, on the arm of my handsome smiling husband, whom I have missed with every other beat of my heart.

Edouard was in a fine and jocular mood. He has received a promotion. To head the London office of his firm. He will leave for England at the end of the week. He picked up his pace

until I was almost running beside him. "It would be wise," he said, "if you remained at the hospital for seven more weeks."

I pulled his arm to make him stop and look at me. "Surely you cannot want me to stay here, Edouard."

He was perfectly composed, almost non-chalant, when he patted my hand. "Dr. Peyron has advised me that significant dates can trigger emotional crises. You should remain here, my dear, under supervision, until the first anniversary of Camille's birth has passed."

"Dr. Peyron! What does he know? He is a retired Navy doctor. An eye specialist!" I thought I detected a look of genuine shock on Edouard's face, and I took the advantage, with a rush of words which may have sounded too much like desperate pleading, "I should go back to Paris with you. If you don't want me coming to London, I would live by myself at *rue du Cherche-Midi*. Or, I could stay with Dominique until after Camille's birthday."

"And what if you collapsed as you did last February? You wouldn't want to be the cause

of undue distress for your sister, would you? As it is, she has her hands full with two little ones and another on the way. No, it is better that you wait here until you have passed that sad milestone."

Edouard has everything already arranged in his mind. At the end of October, if I am healthy, his sister Pauline will come down to fetch me and bring me back to Paris. I told him I was perfectly capable of taking the train all alone, but he waved off my comment.

Then, as his plan goes, I will come to live with you during the last two months of your confinement. He will be back in Paris from Christmas through the celebration of the New Year. At that time, he will determine if I am well enough to accompany him back to London. That is his plan, as he described it to me yesterday, as we walked into St-Rémy on a lovely afternoon.

I was too dazed to continue arguing with him. Besides, a disagreement might have been construed as a tantrum or worse, another accusation of hysteria to justify the necessity for keeping me here.

Edouard led me into the *Hôtel de Cheval Blanc*. Near the front desk, a young servant girl with a slight overbite and braids the color of sand was dusting. She glanced up from her work when we entered, and she blushed before quickly bowing her head and making a slight curtsy. I looked to see if Edouard had taken notice of her, but he was already handing his hat to a waiter and offering me his arm as we stepped into the restaurant. I turned to catch another glimpse of the blushing girl, but she had disappeared.

Edouard ordered for both of us. He selected a bottle of *Champagne*, light and fresh and bubbly. "To celebrate," he said. He took out his pocket watch to check the time.

As the waiter filled our glasses, I asked, "To celebrate what?"

He raised his glass and proposed a toast to Papa. "To your father, who was also a wise and generous friend and mentor to me. He would be proud of my achievement. I am pleased that I have lived up to his faith in me."

I drank to Papa, of course. Then I raised my glass for another toast. "To our dear Camille."

He blinked, no doubt wondering if he had heard me correctly. He drank and dabbed at his lips with the corner of his linen napkin. I sat watching him, spearing escargots swimming in their garlic cream sauce.

With those two sips of *Champagne*, I could feel my perception shift, just as it did when I watched the cheerful young deliveryman more than two months ago. I had another sharp clarity of vision, but this time it was accompanied by a dull pounding around my temples. I noticed each hair on Edouard's head was in its precise place. His hands smooth. His nails clean and clipped. His suit freshly pressed, his collar and cuffs starched, his shoes newly polished, probably all done that very morning by the blushing young servant girl eager to please the handsome gentleman. He smelled strongly of lemon soap.

Handsome, charming and arrogant. It is a lethal combination in a husband. I detested him, then, for his perfection, Dominique, for the elegant ease with which he moves in the world. I detected a streak of cold cruelty in him, too, which I had never seen before. It

was so chilling that I shivered when I saw it and my teeth began to chatter. Did Papa ever see it? I wanted to weep at our blindness.

Our lamb was served. Between forkfuls of food rinsed down with *Champagne,* he talked and I tried to eat. What an advancement it was. How hard he had worked to earn it. Thirty employees working under him. I looked over his shoulder, out the window, at the fountain in the square which is dedicated to Nostradamus.

I interrupted his monologue. "Nostradamus was born in this village, you know. It is said he had visions. He predicted the bizarre death of Henri the Second. He was trained as a physician, and while he was off healing peasants afflicted with the plague, his own poor wife and his children were dying of it themselves. He could not save them."

Edouard acted as if he did not hear me. He commented about my appearance. My face has a pleasant rosy glow, but I need to pay special attention to my hair. The curls are wild and unruly, and it hasn't been properly combed. Never mind that we are not permitted

mirrors in our rooms, and I had no time for a decent coiffeur more to his liking. When I complained of my weight loss, looking like a skinny mop with no bumps and curves, he reassured me that my slenderness is most appealing. He will instruct Pauline to take me to Madame Ferrièr's immediately upon our arrival in Paris so that I may order a beautiful wardrobe that will flatter my slim and delicate features. I should spare no expense. "Most women are eager to retain such a charming and youthful figure," he said, without looking at me, absorbed in slicing another bite of lamb.

He did not once reach for my hand. He smiled only when speaking about his new position and the fashionable flat he will find near Kensington Gardens.

At the Nostradamus fountain, a father lifted up his little daughter so that her hands could grab at the flowing stream. How I enjoyed hearing her shrieks of laughter when she splashed water into her father's face. Each time the water found its mark, he leaned back in an exaggerated way, as if his

little girl was truly startling him. He laughed too. They laughed together.

When the waiter poured more *Champagne*, I proposed another toast. "To you, my dear husband, you who are cruel even in your kindness." I drank another glass and then another.

While he waited for his coffee and apple tart, Edouard checked his pocket watch. He reached into his jacket pocket and took out a small box. He gave me my birthday present. Early, he said, because he would be in London on my birthday, and he didn't want to send it through the mail. Opal and diamond teardrop earrings. Set in twenty-four carat gold filigree, he noted. They are very pretty.

When he looked at his pocket watch for the third time, I had to pinch myself to refrain from screaming and snatching it off its fob. I detest how he snaps that thing shut! Clipping off time, as if it is an inconvenience. Wherever he is, he is always anxious to be somewhere else. I asked if I was going to be allowed to spend the night with my husband at the hotel. "No," he said, a little too quickly and too emphatically for me to maintain a tranquil

spirit. He was taking the train back to Paris within the hour. He did not want to miss work as he has many things to put in order before he leaves for England. He did not seem at all perturbed by how this news might affect me.

I finished my *Champagne* and I asked him, then, for a thousand francs. For a painting I wanted to buy him for Christmas. He gave me five hundred and said he would send the rest when he returned to Paris.

Edouard stopped to retrieve his portmanteau before we left. The concierge rang a bell and disappeared into an alcove behind the front desk. He emerged with Edouard's bag and looked up the staircase. The servant girl was descending slowly, holding onto the banister and dragging the tip of her shoe across the tread before she placed it on the next step. She was sucking on the end of one braid.

"Solange, *vite*," the concierge called to the child. He turned to Edouard, "Pardon, monsieur, there seems to be a misunderstanding. Solange?"

The girl reached into her pocket and held out a twenty-franc gold piece, shining in the

palm of her little hand. Her nails were ragged, bitten down to the quick.

"My wife found this in Solange's apron last night. She said that you gave it to her, monsieur. but it is so generous a gift that we must confirm her story."

"Yes, but certainly, I gave it to Solange. When I was here last May, I promised her a reward if she could recite Hugo's *Vere novo* when I returned." Edouard patted the little girl's head and then pulled one of her braids, the dry one. "I am delighted to report that she gave a rousing rendition of the verse, one which would have impressed and thoroughly delighted the old poet. You and your wife should take great pride of your daughter."

Solange pocketed her prize and skipped down the dark hall. She opened the door, but before she stepped into the sunny day, she turned back with a curtsy and a curious smile. Denoting a shy triumph, I decided. I wondered if my own lips once curled with such knowing when I was her age. Her father gave us a bow and escorted us outside, into the late afternoon. He helped me into the carriage that had

been ordered while Edouard dashed across the square to a florist stand. He climbed in next to me, a little breathless, with a dozen long-stemmed white roses. The roses were exquisite. I cradled them in my lap and bent my head to inhale their fragrance. I let myself sob onto the petals.

It was only then that Edouard put his arm around me and pulled me closer. He took out his handkerchief and mopped up my tears. He whispered, "Please don't be unnecessarily sad, my little Emma. It would be difficult for both of us if you came to London with me just now. I am certain that you will be well enough to come with me in January. In the great scheme of things, that is a very short time when we have our whole long lives ahead of us." He handed me his handkerchief. "Now blow your nose and give us a pretty smile." He helped me out of the carriage, quickly kissed me on the forehead, and then he was off to catch his train.

"Now blow your nose and give us a pretty smile." I will not see my husband for almost four months and those were his last words

to me. Does he think that because I am only twenty-two years old that I have no sense? Does he think that because I have loved and adored him for twelve years that I will tolerate his unusually mean treatment without complaint? And why did he choose a poem about the genesis of a butterfly for Solange to commit to memory? Why not Hugo's verses about the Paris Commune or being a grandfather?

Dominique, this is between us: I did not tell Edouard then what I know now. I think that I shall never be well enough to live with him again. That is how I am feeling today. But then, admittedly, I am still shocked and wounded by what I perceive as his inexcusably callous behavior.

And, yes, of course, you do not need to remind me again of Maman's continual caution: It is better to give in than to give up. I remember. I remember. We will have plenty of time to talk when I see you at the end of October, and I will be open to your advice.

I am coming to understand, though, that I have a secret reserve of strength within myself. Yes, it may be madness to completely lose

one's senses when a baby dies, but surely it is also a pathology to possess a heart of stone. I am not as fragile as Edouard believes me to be. I have every reason to believe that I shall weather Camille's coming birthday with great sorrow, but without collapsing, just as we have grieved on Papa's and Maman's birthdays since their passing, with love and sadness and remembrance of happier times. Still, I have a little doubt, but only just a little, that I may slip again into incoherent darkness. As I wish to spare you any trouble, I will stay here, reluctantly, as Edouard has planned.

As to life here: Yesterday, after Edouard left, I went directly to my room, intending to stay there for the rest of the night with my lovely roses. Much later, there was a knock on my door. It was Sister Epiphany calling softly, "Mademoiselle Subileau is playing the piano again."

I went downstairs to listen. Marguerite was entertaining everyone, boarders and their guests and the staff, with *Nocturnes*. Most by Chopin, I believe, but also pieces by different composers whose work I did not recognize.

Still, the music was divinely beautiful and soothing. It was exactly what I needed to restore my balance.

As I watched her play, the force of her fingers upon the keys, how her thin body moved and swayed to the melodies, I decided to make her a gift of my new earrings in appreciation for her kindness. With her short hair, they will look stunning, dangling from her ears as she plays for us, and sparkling.

Vincent continues to avoid us, except at meals, and he still refuses to go outside. But, he is allowed to paint again! In his studio. He is working on a portrait of the Chief Warder Trabuc. There is no danger that he will try to eat his paints when Trabuc is in the room!

You have asked before if Vincent has talent, and I am pleased to report that you may ascertain for yourself. Two of his paintings—*Irises* and *Starry Night over the Rhone*—are being exhibited at the *Salon des Indépendants*. At the *Pavillon de la Ville de Paris* until 4 October. You cannot imagine how much time was required, how many subtle inquiries were

posed and newspapers skimmed, until I was able to elicit that snippet of information!

Please have no worries on my account. I am learning that I can find a little happiness no matter where I am. Even here, with the likes of Sister Loretta and Colonel LeBrun. At least I will be back in Paris before the closing of the *Exposition*. Please set aside ample time for us to explore it at our leisure if your condition allows it. The future will take care of itself. As for now, Dominique, please eat well and rest often. We must be strong and healthy for each other.

Your sister who misses you, Emma.

St. Paul-de-Mausole
St-Rémy-de-Provence
6 septembre 1889

Dear Dominique, Edouard has advised me that, in his absence, Dr. Peyron would be contacting you and Henri if any problems arise. While I do not think today's incident warrants concern, I do not yet know what Dr. Peyron's reaction will be. I do not want you to worry about me in the event that you do hear from him.

I was involved in a small matter this morning. Actually, it was "much ado about nothing," as Shakespeare would say, though Sister Loretta, that crusty old crow, had a very different opinion.

While we were all gathered at the table eating breakfast, Sister Loretta came marching into the dining room. Yes, she was marching. Marching as if she had been trained in the Prussian army and not a convent! If she had

lifted her skirt, I would have expected to see her wearing a soldier's heavy black boots! Indeed, even her piety seems to be more of a military persuasion than spiritually sincere. Her face was as red and plump as a juicy ripe plum, and in her arms she carried the dozen long stems of the roses that Edouard had given me.

"What is the meaning of this, Madame du Jardin?" she demanded, and not kindly, as she waved the stems toward me.

"The meaning of what?"

She came closer and punctuated every word by shaking the stems in my face. "Where are the roses?"

"The roses? I ate them, Sister." Everyone, even Vincent, laughed. Everyone that is, except Sister Loretta, whose eyes pierced through me like two sharp brown thorns.

"You *ate* them?"

Colonel LeBrun licked his lips and grinned at me. "La Croqueuse du Jardin," he murmured in an admiring way, while reaching for my knee.

I slapped his paw away. "I did not devour the roses, Colonel. I simply ate them."

Madame Bondieu reached for my hand and squeezed it gently. For a moment I fervently wished that she would burst into a medley of Prussian drinking songs, and I coughed into my napkin to avoid giggling out loud at the idea. Sister Loretta stamped her foot and rapped the stems on the table in front of me to regain my attention. She repeated, more forcefully, "You ate them?"

"Yes, I ate them. They were so lovely. I couldn't allow myself to watch the pretty petals turn brown and die."

Sister Loretta shook the stems at me again, swatting the air close to my nose as if I were a puppy who had piddled on the carpet. "We shall see what the doctor says about your bizarre appetite. Go directly to your room when you leave the table." Before I could say another word in my own defense, she turned on her boot heels and stomped out of the dining room. On her way, there was no doubt, to report me to Dr. Peyron.

In a soft low voice, Marguerite muttered, "*Quelle salope.*" We were all stunned that Marguerite, of all people, would apply such a vulgar term to a *religieuse*. We chuckled at her, but only she had the courage to say aloud what the rest of us were surely thinking.

Everyone at the table was looking at me, silent, nodding with sympathy, I believed. I couldn't keep from laughing. "The roses were quite tasty, actually. Better than cabbage."

Vincent smiled then, a pleasure we have not seen for too long a time. He said to us, "Emma once told me that one may live without bread, but not without roses. Apparently she takes Jean Richepin's advice quite literally. To La Croqueuse." He raised his coffee cup, as if toasting me, and the others raised their cups too. It was a merry and bright breakfast then, despite my protests that I did not devour the roses, I only ate them. Slowly. Petal by pretty petal. It seemed that Vincent was no longer isolating himself from our company as carefully as he has in past weeks, as he joined in the table conversation, quite naturally, of his

own accord. He even seemed to be enjoying himself a little.

When Vincent got up from the table, I seized the opportunity to take him aside. I asked him to do a portrait of me. He looked over my head down the hall. In the uncomfortable silence, I wondered if he might walk away as if he didn't hear my request. Finally, he spoke. He said that he was more accustomed to painting peasants and working people. He said that he finds their faces infinitely more interesting and worthy of study than the face of a young *bourgeoisie*. As if to apologize for the insult, he quickly added that he did not think he could do justice to my face. "Dutch women are not so soft and sweet about the face as French women," he said.

"What a diplomat you are, Vincent. Surely you exaggerate. I have been to Holland. I've seen the women there." I explained that I would be willing to pay him five hundred francs for my portrait, plus the cost of canvas and paints.

He hesitated, seeming to consider my offer, and then he explained that currently

he is hard at work, at a furious pace, on the portraits of the Chief Warder Trabuc and Madame Trabuc, and he is also touching up two self-portraits, one which he started while he was ill.

I was relieved to hear from his own lips that he is back working on his art so conscientiously, as that has been a particular concern of mine. "Please consider my offer. It would be a great favor to me," I said. "There is no hurry to decide. I will be here until the end of October." That is the way my request was left.

I am back in my little room, musing in my journal about whether Dr. Peyron will deem me manic for eating roses, and if I will be subjected to a bath this afternoon. But, it is just as I told Sister Loretta: I could not bear to watch the beautiful roses die. Nor could I throw them away.

Now to cheerier thoughts. . . Yves or Yvette! Yes. I think you do Papa a great honor to name your baby after him. How I should have loved to see the wide-eyed looks on Gaston and Louisa's face when they felt their little brother or sister kicking inside your belly! And to hear

their carefree giggling too. What fun you must be having! When I was pregnant with Camille, I noticed that she kicked often and hard when I ate anything with garlic. Perhaps your little Yves or Yvette is sensitive in that same way?

Six more weeks until I see you, Dominique! And then I can watch the bulge moving in your belly and feel the baby kicking for myself, perhaps as we are all sitting out on the *Champ de Mars*, entranced by the electrical illumination of the *Tour en fer*! I am relieved that your harsh opinion of the *Tour* has softened since its completion. Its astonishing height and Eiffel's engineering ingenuity are the envy of the world, as it should be.

Please take good care and have no worries about me. With love and affection, Emma.

St. Paul-de-Mausole
St-Rémy-de-Provence
14 septembre, 1889

My dear Dominique, I am so happy and excited, I can barely contain all these wonderful sensations rushing through me, let alone attempt to describe them! But write I must or surely I shall burst—though tonight words are poor flimsy vessels in which to carry any substantial thoughts. Please forgive this letter if I ramble in a thousand directions. My thoughts and feelings are racing this way and that until I am quite stupendously dizzy with joy!

I have been to Vincent's studio! I have seen his art! Disguised as a tentative man wearing a common artist's blue smock, he is a true genius, and a busy one at that!

Yesterday, I went uninvited to Vincent's studio to return *Richard II*, which he had lent to me before he left for Arles, before he

became ill. It is a large, spacious and airy space on the ground floor, with tall arched windows overlooking the front garden, and it was full of his canvases, some of which he is preparing to send off to his brother Theo in Paris, and some which are still drying on stretchers.

Dominique, I wish I could provide a detailed list of everything I saw yesterday, but there was too much to see. No, to be more precise, there was too much to feel! I counted more than twenty large canvases, some he called "Studies" and others, "Pictures," though to my untrained eye, there seemed to be little technical difference between the two designations. And then there were also "Reductions," small canvas copies of his larger work. Green wheat fields, yellow wheat fields, fields of poppies and olive orchards. Cypresses. Mountains. The hospital vestibule where I first saw him standing. A long hospital corridor, with its many arches.

I tried to be very careful, to guard against my exuberance. I did not want to scare the poor man, as he has been so cautious in his

associations with us since his collapse. But I wanted to dance about the room, and touch and hug and kiss everything! Which was my favorite? But it was impossible to choose! I imagine it is akin to loving your children. You celebrate their different attributes and personalities, but you love them all without reservation, and you revel in having them around you.

There were several glorious paintings of the lush green underbrush in a secluded corner of the asylum garden. "That is no undergrowth," I wanted to tell him. "It is my ivy bed!" Vincent has captured the exact spot, that divine, luscious little corner of the earth, where I have taken to sleeping on occasion! I wanted to caress each and every one of his brushstrokes with my fingers so that I might feel on my own skin his vigor and the turbulence and agitation of his lines.

There are two paintings which he calls, *The Reaper*. One he did last June, shortly before he was incapacitated by his illness. It is a canvas almost completely covered with "*impasto*," thick layers of a wonderfully cheery

golden yellow paint. It made me happy to look at it. Then, to my amazement, Vincent confided, "The reaper is an image of death, but what I have sought is almost smiling."

It sounds macabre, Dominique, but he achieved what he was seeking! Brilliantly. In the past week or so, he has done another rendering of this scene. Not an exact copy, but a re-interpretation painted in his studio, with the sun higher in the sky and a thin tree added.

To my mind, the studio study is not as forceful as the one done from nature. When I expressed this opinion, Vincent began a long monologue which thoroughly mesmerized me. I sat on his collapsible stool, the one he designed himself and uses when painting outside, while he paced about the room and expounded on his philosophy of art. He took a piece of blue chalk from his pocket and made quick sketches on the floor tiles to demonstrate what he meant. While he rubbed away the marks with the toe of his boot, he described his dream for a Studio in the South, which he had attempted to establish last year

with his friend, another artist, Paul Gauguin. What he envisioned seemed very like the colony in Barbizon which we once visited. You remember, near the *Forêt de Fountainbleau?* Apparently there was some terrible falling out with Gauguin. Vincent hesitated then, struggling for words, it seemed to me. Or perhaps he was simply weighing the wisdom of divulging the details of their dispute.

In any case, I used the awkward pause to ask if he wouldn't like to stroll about the garden while he shared his fascinating ideas. He glanced at the window and quickly turned away. He shook his head, and he refused my invitation to go outside. "There is something about the wide space," he mumbled, "which makes me dizzy. And lonely."

He went on about his difficulties with Gauguin while they were in Arles. He spoke about the contrasts in their temperaments, style and techniques. One of their major differences was whether to paint *en plein air* or *en tête*. His friend Gauguin prefers to paint from memory, while Vincent...Vincent, I think, does his best work when nature is immediately

in front of him. I saw this strength in the two versions of *The Reaper*, and I felt it, too, in another marvelous painting, which he called variously *A Study of Night* and also *Night Effect*, a sky of haloed stars swirling above a sleeping village.

"Is this a copy of the *Starry Night* being exhibited in Paris? I asked.

"No," he said. "This one I painted here, last May, while looking through the iron bars of my bedroom window."

"That is the one good thing about our rooms, isn't it? We do have a spectacular, view of the sky, don't we? Your painting is exceptionally beautiful, Vincent. Powerful. The colors are striking! And, how vast the sky, in contrast to the small village and the tall dark cypresses stretching from the earth into heaven."

We stood, in silence, very close, swaying together in harmony, as if we were moving, dancing, to invisible music inspired by the curling, whirling, twirling, swirling sky he had painted. We gazed at the canvas until Vincent cleared his throat. "I am thinking of Walt Whitman's poem *From Noon to Starry*

Night. Do you know it?" He did not wait for my answer, but instead recited from it:

> "Prepare the later afternoon of me myself—prepare my lengthening shadows, Prepare my starry nights."

I could do nothing save stand still and savor the moment. I closed my eyes and allowed the resonance of his deep voice to wash Whitman's words through me.

He broke my trance. "With my illness, I can never be more than a fourth or fifth-rate artist."

I did not know whether to comfort him with a warm embrace or cuff his head. "Rubbish! What nonsense! You are greatly mistaken, sir. Have you not read what Zola says of himself? 'I am an artist. I am here to live out loud.'

"The same may be said of you, Vincent. Your work blazes with all the power and energy of the Provençal sun that you have captured with your eyes, your heart, your brush, and your soul!

"You must not doubt your talent. It is loud and true and original. I wish for all the world that I had your artistic vision and the skill to commit it to canvas."

"There is nothing more artistic than to love people," he said.

I could feel myself flush, not knowing, really, how to interpret his remark. "There is some hope for me, then, as I am all thumbs when it comes embroidering, playing the piano, or drawing even the simplest of objects.

"But what is the nature of your illness which you believe confines you to third-rate status?"

"Dr. Peyron has spoken of epilepsy, as has Dr. Rey, who saw me in Arles. But neither has confirmed this diagnosis. Dr. Peyron has told Theo that if it is, indeed, epilepsy, then there should be concern for my future."

Vincent changed the subject by directing my attention to two self-portraits. He asked me to guess which was the one he had started when he was ill. It was not difficult to distinguish one from the other. The one, of him in

good health, he is going to send to his mother for her seventieth birthday.

I also saw the portraits of Trabuc and that of his wife. They are excellent likenesses. One can sense in his work the profound respect Vincent holds for them. He told me that Trabuc formerly worked at a hospital in Marseilles where there were two cholera outbreaks. Of Madame Trabuc, he said that she was a "poor soul resigned to her fate...a dusty blade of grass." He spoke of her gently, and with great admiration. He has already begun to paint copies of the two portraits to send to his brother.

He has also been copying from Millet's *Labors of the Field* and Delacroix's work. He has painted Delacroix's *Pieta* from a black-and-white lithograph which was damaged by spilled oil when he was ill. Mary is all in blues, with the unmistakable facial features of Sister Epiphany. I noticed, too, Vincent's resemblance in the face of Christ. Surely it connotes the suffering he endured while ill.

"But why are you copying," I asked, "When your own work is so good?"

"Many people do not copy, many others do—I started on it accidentally, and I find that it teaches me, and above all it sometimes consoles me.

"It is the study of figures," he continued, "that teaches you to seize the essential and to simplify. I have no models at the moment."

"Have you considered yet whether or not you will paint my portrait?" The instant the words escaped my lips, I regretted my impetuous question. I can only attribute my spontaneous utterance to my aroused response in viewing his extraordinary talent for the first time.

Vincent looked out the window, as I did. Just beyond the sill, a late-blooming rose was losing its petals. To my amazement, he said, quietly, "I have some time tomorrow."

How much time passed in his studio, I do not know. It must have been hours, but it felt like only a few moments, and too brief at that, like the stirring remembrance of a dream upon awakening, when I want to close my eyes and hurry back into the dreamland because it ends too soon. When I left

his studio, my head was spinning and my knees were so wobbly and weak that I had to sit down in the hall before I could climb the stairs to my room. At dinner tonight, I could scarcely touch my food.

It is almost time for bed, but I'm not sleepy at all. Do you remember when Papa had us pose for Monsieur Renard? How tiresome it was? I think the poor man spent more time fiddling with the bows in our hair and straightening our shoulders than he spent at his easel. How Papa loved that painting! And how angry Maman was at its exorbitant price!

I have no concerns about becoming bored tomorrow. To the contrary, I am worried that I shall be too stimulated to sit still even as long as one minute. I think of all the incredible paintings I saw today. I think of Vincent's talent compared to that of old mediocre Monsieur Renard. No comparison can be made. Mama was right to complain about Papa's extravagance.

More tomorrow. After I have had my first sitting.

Continued. 15 September: I did not sleep well last night. I was overly excited about having my portrait done, and I tossed and turned. I needed to go for a long walk in the fresh air to relieve my nerves, but my door was locked. In the dark, I paced the length of my room and back, all seven meters of it. By the third roundtrip, I was so agitated that I threw myself back down on the bed. For the first time since my arrival here, I felt truly imprisoned, caged.

I tried to relax. I envisioned myself sitting on the beach in St.Tropez. But it did no good because I thought of the Trabucs, and I became nervous and extremely self-conscious. Of Monsieur Trabuc, Vincent had said, "He is a man who has seen an enormous amount of suffering and death, and yet there is a sort of contemplative calm in his face."

What would Vincent see in my face as he painted? Certainly not calm nor serenity. Would he see a spoiled young woman whose face is unmarked by the ordinary hardships, stresses and strains of life? A woman who holds secret sorrows? A woman accustomed

to luxuries enjoyed, but never earned with honest work? A *haute bourgeoisie* towards whom he might harbor disgust and disdain if he passed her on a grand Parisian boulevard?

I began to regret the conceit of my offer. It was more than shyness; I began to fear how Vincent would view me. It was too upsetting to contemplate. I became so troubled that I trembled and became nauseated at the prospect of enduring his prolonged scrutiny. As soon as I decided that I would not pose for a portrait after all, that I would simply purchase one of his paintings of the magnificent underbrush in the garden, I was able to sleep.

I had a dream. A long, complicated dream, but the only image remaining in my mind when I awoke was a vision of Ingres' *Grande Odalisque.* How often have we admired that painting at the Louvre? She was, of course, the solution to my dilemma!

I began posing for Vincent this morning in his studio, under the watchful eyes of Madame Trabuc, whom I hired as a chaperon. It wasn't necessary for my sake, but the good sisters might have a very different view

of things. Also, I thought Vincent would feel more comfortable, as he considers Madame Trabuc a trusted and unthreatening friend.

Vincent nodded in my direction when I entered his studio, and gestured toward a tall stool across the room, indicating where he wanted me to sit. "I'll sketch first, if you don't mind."

I turned my back to the easel and unbuttoned my blue tea gown. When I let it slip to my waist, Madame Trabuc gave out a gasp and started protesting in a loud, rushed whisper. I sat down in front of a window, with my back to Vincent. "But it is a present for my husband, Madame," I assured her. "It is what he expressly requested of me."

It was only a little white lie, Dominique, and I am sure that God will forgive my transgression. It is imperative to keep Vincent occupied with his work. As he himself has said many times, it calms him to be painting. It is his salvation, he believes.

Madame rose with a finger to her lips, and I think I saw a wink. She drew my tea gown loosely back over my shoulders, walked

across the room and closed the heavy studio door. From her apron pocket, she withdrew a large ring of keys, looked at each closely until she found the right one, and locked the door.

She came back to me, arranged the top my dress into neat folds about my waist. Standing back, she studied the effect, then made another few adjustments and returned to her chair.

Vincent's eyes were on my bare back. I could feel the penetration of his gaze. For long minutes there was absolute silence in the room. Then, finally, the sound of pencil on paper. Double Ingres paper, he told me. Short strokes. Long strokes. Hurried strokes. Slow strokes. Scratching. Streaking. Slashing. Snap. The breaking point.

The broken pencil was thrown to the floor. I heard Vincent's fingers fumbling for another, and I took a long deep breath. I could hear him attaching another piece of paper to his easel. Then the sound of pencil on paper. My body instinctively began to move in rhythm with the strokes. I could feel on my own skin, a prickling, in response to the sound of friction,

the leaded point pressing down and moving, moving. I realized that I was holding my breath, and I struggled to inhale and exhale slowly, as imperceptibly as possible. There was the click click click of Madame Trabuc's tatting needles working on a doily. Vincent did not speak and neither did I. Somewhere far a dog barked and closer, just outside the open window, the chittering of magpies.

I sat, commanding my body to remain perfectly still and remembering to inhale. I wanted to watch Vincent's face as he worked. I wanted to look into his blue-green eyes. I knew I would see passion there. Passion not for me, but for his creation. I wanted to know his passion. I wanted to feel it inside me. I wanted to gaze at his large, rough hands. Observe the movement of his broad shoulders, bending toward the easel. I wondered if he sat before his easel as Marguerite sits before the piano when she is unleashing her passion up and down and across the keyboard.

How foolish I was! Because of my small vanity, not wanting to know how Vincent would commit my face to canvas, I denied

myself a unique opportunity to watch his passion as he worked.

The sound of the pencil stroking the paper, then attacking it, and stroking it again, but softly, with lighter pressure. The constant clicking of Madame's needles. I made myself breathe slowly and diverted my attention towards the garden. The pine trees. Tall grasses. Trimmed hedges. The stone wall and the Alpilles in the distance. Up close, the last fading roses of the season. One, particularly stunning, a red rose with a radiating golden glow, like the sun, at its center. The afternoon sun flooded the room and I grew hotter. Even half naked I could feel steam rising from my pores.

I began to feel light-headed, and I blinked to shake away the dizziness. When I opened my eyes, I experienced that same strange perceptual shift I have previously described to you. I could see, clearly, outside the window, another scene. The night. Luxuriating in the coolness of ivy. Just as I am. Bare and unburdened. Offering myself up to the warm embrace of the universe. At one with the

musty smell of dark earth, yet soaking in the radiance of moonlight, under a host of sparkling stars sprinkled across the sky like silver confetti.

When I shook my head to revive my senses, my tortoise-shell combs clattered to the floor and my hair tumbled down my back. Madame Trabuc stood up to retrieve them, but Vincent...Vincent stamped his foot and yelled out, "No!" I hardly recognized the voice as his. I turned my head in his direction just in time to engage his eyes before he bent down and rummaged through a box for another pencil. He began sketching again.

There was a loud pounding at the door. Sister Loretta was yelling. "Vincent, are you in there? Vincent?" The doorknob was turned and turned again, and then rattled. More pounding. "Vincent? You are forbidden to work with this door closed. Open it immediately!"

Madame Trabuc stood. "It's all right, Sister Loretta. I am here with Vincent.

"I saw a mouse and I closed the door before it escaped out into the corridor and frightened someone."

"But the door is locked, Madame."

"Yes, yes. How silly of me to lock it. I'll open it at once. Let me find the key." She made a point of jangling her keys. I quickly buttoned up my gown and looked for my combs on the floor while Vincent took the drawings he had been working on and put them under a pile of other papers. He attached a clean page to his easel, and began to quickly sketch— what I saw later as a rendering of Madame Trabuc's face.

If it had been any other nun, there would not have been such an effort to conceal our project. But Sister Loretta has a propensity for inflicting cruel punishments for the slightest infractions. Her reputation is well-deserved.

Madame Trabuc opened the door, just a crack so that Sister Loretta could not see inside. She stepped outside just enough to block Sister's entrance. "Vincent is just leaving now. To get one of the cats. The big grey one, Vincent, he will take care of that pesky mouse." She locked her arm around Sister Loretta's and began leading her away. "I forgot to ask you this morning to show me the

new bronze crucifix donated by Mademoiselle Subileau's parents."

Vincent smiled at me and followed them down the corridor.

Thus our first session ended. It was not as difficult posing for Vincent as it was for Monsieur Renard. He made no references to my posture nor did he fuss with my hair. I am to return to his studio tomorrow after lunch.

A brief letter from Edouard was waiting for me in my room. I felt as if I was reading a letter from an acquaintance, and not one from my husband. Was this due to my own disappointment? Edouard did not once mention that he loved me or missed me. Or was it the sterility of his factual recitation? Perhaps both. He enthused on and on about his new position, as if written in a fever. He has already been to the theater. To see Grein's production of Henrik Ibsen's *A Doll's House*. It was a severe letdown to him because, from the title, he was expecting a comedy. He has found a spacious flat on Bayswater Road across from Kensington Gardens, although he has not yet leased the rooms. It is most

vexing that I do not know where he is staying. A club? Hotel? The only address I have for him is his firm's address. I feel unduly constrained in my communications as it is hardly appropriate to write of marital relations when clerks might be opening his mail. At any rate, Edouard sends his regards to Dr. Peyron. He sends warm regards to you and your family. He sends warm regards and kisses to me. I did not read his letter twice as I usually do.

It is a good thing that these past two days have been so interesting, otherwise the chill of his letter might have reduced me to an afternoon of tears and a sleepless night of doubts. As it was, I went to find Madame Trabuc to ask if she would please accompany me on a long walk about the countryside, and that is exactly what we did for two hours before supper.

My head and heart are much too full to write anything further, even in my journal. I wish I had had the forethought to remain outdoors this evening, for tonight I should love to be settling down amidst the luscious ivy. But it is too late; my door is already locked.

Wishing you continued good health and abundant energy, your sister Emma who loves you.

P. S. I have just received your note in the morning mail. I appreciate very much your gracious offer to travel down here for my birthday and to support me in what will be a heartbreaking commemoration of Camille's birth. But, no, Dominique, please do not consider such an undertaking in your condition. I am in capable and caring hands.

I trust that you will also strongly discourage Aunt Sylvie from a trip to see me. Can you imagine her horror when meeting the other boarders? Even if she wore three veils, one glimpse at our menagerie, and I fear that she would fall into a fatal fit of apoplexy.

Kisses to everyone, Emma.

St. Paul-de-Mausole
St-Rémy-de-Provence
13 octobre 1889

My dear Dominique, A thousand kisses and hugs for this beautiful new journal! You wrote that we would be celebrating my birthday when I returned to Paris so I was expecting only a letter. I was completely and most happily surprised. And not just for the elegant volume waiting to be filled, but a letter from Georges too!

How smart of him to send his letter for you to forward rather than expecting such kindness from Aunt Sylvie. She is furious. She blames me for Georges' sudden urge for a *Wanderjahr*, and I will be very fortunate to see her at Christmas, or so she threatens. I will gladly forego her traditional over-cooked goose with that dreadful chestnut purée to read Georges' hilarious accounts of his adventures. Did you wonder, as I did, when

he became such a charming wit? So he follows in the footsteps of Flaubert and du Camp in Egypt, but he had me chuckling with his very first paragraph and its description of his fellow passengers on the Mediterranean crossing. My word! Who knew that so many English ladies and their mothers were eager for a match with a French medical student. To suggest the attraction was the savory veal cutlet in his pocket—well, that was a rather unkind depiction of his worshipping *coterie* and surely it wasn't accurate, but it was funny—especially coming from our staid and sober cousin. I've dispatched a rush letter to Port Said that I'm hoping will reach his ship before it passes through the Suez Canal. After that, I do not know his itinerary. I'm not even certain that Georges himself knows, judging from his letter.

You ask about my portrait. The one Vincent began in his studio, in which I am posing as an *Odalisque* with my bare back to the easel, is not yet started in oils. He won't allow me to see the sketches, which has been most frustrating. However, Vincent has completed

another portrait—one that I will prefer to any other thing in the whole of this beautiful world.

We arranged the sitting exactly as I had envisioned it while I posed in his studio last month. I thought that he might be coaxed to venture outside if it was dark and the wide space was not so intimidating, and he finally agreed to try. We waited until last week for the full moon in October, a moon so bright that I could almost detect the changing color of his eyes as he surveyed the scene before him. We began the night before my birthday. For three nights, he painted me *au naturelle*, reclining in my ivy bed, what Vincent has called, and rightly so, an "eternal nest of greenery for lovers."

I am reluctant to share more intimate details of its composition in a letter, even one that is written in English, except to say that the portrait work is magnificently stunning in its coloring, tone and execution. The power of his passion and the brilliance of his brushwork are inspired. Most certainly it is

his best work to date. And his hands were not so rough upon my skin as I had imagined.

On the third night, after the portrait was finished to his satisfaction, we lay on our backs, embracing, gazing up at the bright cloudless sky. In a low voice, barely more than a soft whisper in the breeze, Vincent began reciting:

> "This is thy hour O Soul, thy free flight into the wordless, Away from books, away from art, the day erased, the lesson done, Thee fully forth emerging, silent, gazing, pondering the themes thou lovest best, Night, sleep, death and the stars.

"How eloquently you express the mood. Your words paint every bit as well as your brush, Vincent."

He laughed. "You don't recognize the poem? Walt Whitman. *A Clear Midnight*."

"Please let me hear it again. I want to remember it always."

We talked until just before dawn when the birds started singing, and reluctantly we had to leave our hidden nest. A few hours later, when I came to the table for breakfast, there was a folded note next to my plate. Vincent was not going to join us, but he had copied out *A Clear Midnight* and left it for me. I was told that he was already outside—and painting!

Those lines of *A Clear Midnight* were the last words I wrote in the journal you gave me last May. The last few months of my twenty-second year are chronicled there, and the pages are full of ink and sometimes smeared with tears. How fortunate I am to receive from you a new journal for my birthday! Yesterday morning I took Vincent's note and my new journal to the garden, and copied the passage again. It seemed a beautiful and fitting way to start this new year of my life.

We did not see each other until the evening meal. And what a lovely time it was! We were all in a festive mood. Jubilant. Laughing. Madame Bondieu defused what might have become a dangerous physical altercation.

It started innocently enough towards the end of supper when Madame Bondieu leaned close and whispered, "Vincent can't take his eyes away from you, Emma. He's been gazing at you as he did on the first night he ate with us. Except tonight he can't stop smiling long enough to eat."

Colonel LeBrun overheard her remark and announced to the table, "Vincent is looking at Emma, and he's not looking the way a father should be looking at his daughter."

Madame gave him a kick under the table. "You fool, there are other ears." She nodded toward the kitchen door.

Monsieur Morin pounded his fist on the table. "Of course Vincent is not looking at Emma like a father. He is not her father. He is not old enough to be her father. But you are, Colonel, and that has never stopped your hands from groping her. Or that one infernal bug-eye of yours from ogling her like a madman."

Marguerite started giggling. She rose from her chair and walked round and round the

table, giggling still, but trying to stop herself by covering her mouth with both hands.

"This one eye of mine, Morin, may have lost its mate fighting off the Prussians in Metz, but it saw enough action for two."

Monsieur Morin placed his *pince-nez* on his nose and seemed to study the Colonel's face. He leaned back and laughed heartily. "Ah yes. The sacrifice of our Colonel here gives new meaning to the phrase, 'Keeping an eye on the enemy.' So we have you to thank for our loss of Lorraine, eh?"

The Colonel got up from his chair abruptly, knocking it over. "I served proudly under Maréchal Bazaine in the *Armée du Rhin* of the Second Empire. If that little prick Napoleon the Third had given advance thought to France's defense, our cannons might have matched those of Krupps.

"And where were you during the Siege of Paris, you old devil? Petting squirmy silkworms to arouse yourself?"

Monsieur Morin reached for his cane and straightened up in his chair. Madame Bondieu slapped butter on a piece of bread

and shoved it into the Colonel's hand. "Eat this," she commanded.

"Messieurs, during the Siege of Paris, if you would like to know," she began, "I was in Firenze, with the most energetic and demanding of lovers." She began to fondle her breasts, a sight which never fails to pique the interest of the Colonel, whose one eye always seems to pop out of its socket on such occasions.

"Your beautiful breasts are like cannons, Madame," he murmured, and reached to touch them.

Madame swatted his hand away and continued, "I was singing the lead role, Gilda, in *Rigoletto*. My insatiable lover played the Duke to perfection." Madame took a sip of water, cleared her throat, and sang *Caro Nome*.

"Any other requests?" She looked around the table, at the Colonel and Monsieur Morin and then at me. "Oh, I know. But of course!" She clapped her hands. "From *Martha*. I did not have the pleasure of performing this on the stage, you understand, as I was only Lady Harriet's servant. I accepted the part for

purely sentimental reasons. And now, for *La Croqueuse!*"

She sang *Letzte Rose*, Dominique. I have never heard it sung so beautifully, even when we first heard it sung in London as children. Madame Bondieu's countenance seemed to transform before my eyes, and I saw her as she must have appeared thirty or forty years ago. All summer I have studied her face, trying to look past the wrinkled ravages of time, the heartaches and insensibility, to find the acclaimed soprano and actress she purports to have been, to no avail. Last night, she was there, at her finest. Most assuredly, so touching was her performance that I would have wept if I hadn't had the joy and pleasure of the past few days to sustain me. By the time Madame had finished her air, Colonel LeBrun seemed to have forgotten Monsieur Morin's insult, and was helping himself to another baked apple. I embraced her with my arms and a grateful heart.

"The words to *The Last Rose of Summer* are from a poem by Thomas Moore, a friend of Shelley and Byron," I explained to the group.

"I first heard it in London. That's where I was during the Siege of Paris, gentlemen, playing with my dolls and my tea set."

When we left the table, Vincent excused himself, but the rest of us assembled in the drawing room where Marguerite was already waiting at the piano. She began playing a Chopin *Prelude*, the fourth, I think, but she was not halfway through, when she shifted into *The Last Rose of Summer*! After she finished, I asked if she might allow Madame Bondieu an encore with her accompaniment. And then the Colonel, of all people, rose to sing too! His voice is not bad, a passable baritone. Next we were entertained with some Offenbach tunes, with Madame and the Colonel supplying the vocals. I fell asleep leaning against Monsieur Morin's bony shoulder.

Unhappily, the oil portrait that Vincent has painted of me will not be dry before I leave. Vincent has offered to send it to Paris, but I have requested that he keep it here, safely under his care, until I return to pick it up myself. I will not trust the task to anyone else.

In your birthday letter, you did not mention if you had been to the *Pavillion de la Ville* to see Vincent's paintings. Were you able to visit before the exhibit closed? Please, Dominique, have Henri contact Vincent's brother Theo van Gogh at Goupil's to purchase one of the paintings, or both, if they have not been sold already. Or, ask that they be put aside until I am back in Paris in two weeks time.

I have experienced joy of miraculous proportions these past few days, Dominique, and also a large measure of quiet happiness and contentment. But the anniversary of Camille's birth fast approaches, and I cannot be certain of myself. Will I collapse into darkness and incoherence as I did last February? In the event Dr. Peyron notifies you that I am incapacitated, please do not come here and do not send Henri or Aunt Sylvie in your stead. I have spoken to Sister Epiphany, Madame Trabuc, Madame Bondieu and Marguerite; they will all be vigilant for signs I am slipping away. Sister Epiphany also assures me that Sister Loretta will not be allowed to tend to my needs, whatever they might be. She's

been temporarily assigned to the Incurables wing until my departure. Sister Epiphany has taken my letter of complaints to the Bishop, and I expect that very soon Sister Loretta's nursing career will be altogether ended. Another blessing from this unexpected and strange sojourn of mine.

I end this letter reluctantly. Before the postman arrives, I must compose a letter to Aunt Sylvie, full of contrition for encouraging Georges' foolish vagabondery. At least I can write sincerely that I am very sorry for her loneliness.

I send you and yours love and affection which I will be able to deliver in person very soon, Emma.

St. Paul-de-Mausole
St-Rémy-de-Provence
23 octobre 1889

Dear Dominique, This is, perhaps, the last
letter I shall write from St. Paul's. I have
been weepy for the past two weeks, and no,
it is not strictly my grief on the anniversary
of Camille's birth which fills my eyes with
tears. I trust you received my telegram that
I was weathering that sad day, and all the
days since.

I find I have become attached to this place
and to the other boarders. If I were not so
eager to be with you, dear sister, and to play
with Gaston and little Louisa, I should be
quite content to stay on through December,
although Colonel LeBrun tells me that the
food here in winter is all but inedible.

I sent some of my clothes off to Paris this
morning, many I will leave here for Marguerite.
Except for my *Sonnets from the Portuguese*,

my collection of books will remain at the hospital, the beginnings of a reading library for other boarders and the good sisters. I hope you have no objection to my leaving them behind, as you purchased so many of them for me. It is an act of charity that we can well afford. I was sustained for many long hours by the companionship of this literature, and I know there will be many who follow me in this place who will find comfort in those pages as well.

I have tried to stay busy these past weeks by deciding on gifts to give to my friends and arranging for surprises. I gave Madame Bondieu my combs for her hair and also the ivory fan I purchased in Barcelona when Edouard and I were there the week after our marriage. How can she sing *Carmen* without a proper fan? For Monsieur Morin, I have ordered Darwin's *Origin of Species*. I have never seen him reading, but I thought it was the sort of book that would appeal to his scientific nature. I bought sheet music for Marguerite Subileau as she is more frequently at the piano these past few months.

Last night she favored us with a rendering of Debussy's *Clair de Lune*. Her playing was soft and lovely beyond words, and my earrings did sparkle on her more beautifully than I had imagined they would. I gave Colonel LeBrun my copy of *Les Fleurs du mal*. Perhaps Baudelaire's poetry may inspire him, as if he needed any encouragement! I've also ordered *Nouvelles Histoire Extraordinaires*, a volume of Baudelaire's translations which contain most of my favorite Edgar Allan Poe's stories. I bought Monsieur Trabuc a new pipe and a bag of his favorite special blend of tobacco, and to Madame Trabuc, I gave the coral cameo brooch that I bought while traveling in Naples with Edouard. Most of her clothing is black, and I think the brooch will be quite prettily set off to advantage. For Dr. Peyron, I bought a silver flask which I have had engraved with his initials.

For the group, I arranged two surprises. The first, a photographer to take a picture of our menagerie! My thought was to pass it along to Vincent so that he could paint a portrait of us. He has great contempt for

photography, I know, but he copies from lithographs, so why not photographs too? I thought it might give him something to do when the weather turns cold and rainy.

The photographer was supposed to be here yesterday, but Dr. Peyron received late word that he had been delayed for unspecified reasons. Who knows, now, if he will come before I take my leave. It will be a great disappointment if he does not arrive in time. Once I am back in Paris, and alone, it would cheer me to imagine Vincent's portrait of our group hanging above the piano in the drawing room. Perhaps it would also serve as a message of hope to future boarders who pass under the arches of this hospital.

The other surprise will be at our last dinner together. I have ordered and received four tins of *foie de gras* from Hediard's, and I prevailed upon Dr. Peyron to be allowed wine with dinner! He consented, and I have already bought the *Gewürztraminer*, which will be a perfect accompaniment to the *pâte*. It was carried into the kitchen this morning by my handsome delivery boy, and I was there to

receive it and personally hand him a twenty-franc gold piece for his efforts. It made him happy to receive it, and he even offered me a little bow of respect. As the *Gewürztraminer* has the unmistakable smell and taste of roses, I also bought a bottle for Sister Loretta to share with the other good nuns who might be inspired by the wine to eat rose petals themselves. For Sister Epiphany, I ordered *The Autobiography of St. Theresa*, and I will also leave 500 francs with her so that she has private funds to tend to the emergency needs of the sisters and boarders, as she sees fit.

In my telegram, I promised to provide more details of the somber occasion of commemorating Camile's birth into this world. Last week, on the morning of what would have been the first anniversary, after breakfast, I stood and waited in the vestibule for the postman. Madame Trabuc met him at the door, as is her custom. I watched her sort through the packet of mail. Although she understood why I was there, I was compelled to ask directly, "Anything for me?" She went through the envelopes and shook her head.

And then, perhaps because of the look on my face, she looked at each envelope again.

"No, there is no letter for you today, Emma," she said. "Were you expecting something?"

"Only hoping. Today..." I stopped myself because I would have unleashed a flood of tears if I had finished my thought. I took myself to the stone bench in the wild part of the garden, and wrote in my new journal. I wrote down every detail of Camille's arrival, how long the labor while you stayed beside me, offering unwavering solicitude throughout. How especially relieved I was that you were there to insist that Doctor Fouquet did not use the Tanier forceps he brandished, even after I specifically and emphatically told him several times that I did not want my child to be yanked into life nor did I want chloroform administered. I wrote of my exuberation when I heard her lusty wailing even as I lay exhausted and aching. I wrote of the delicious quickening as she suckled at my breasts. I wrote of her blue eyes looking at everything around her, taking in the world, and her sweet face lost in sleep. I wrote of

my tremendous sadness that Edouard was so far away, and I had received no letter from him, not even a brief note acknowledging her existence.

I poured my pain onto the pages, as Sister Epiphany has suggested, and now your beautiful gift has been christened with tears of sorrow and disappointment. I wrote furiously until Madame Trabuc appeared and sat down beside me on the stone bench.

"It is almost time for lunch."

"I am not hungry today, Madame."

"Monsieur Trabuc and I are going to Arles. We won't be back until late. Very, very late."

I wasn't certain how I was meant to respond. She lifted my hand, dropped a key into my palm and closed my fingers around it. "Allow yourself to be comforted today, Emma. I lost three children to cholera when we lived in Marseilles. You should not be alone."

"But, Madame ..."

"I may be going deaf, dear, but there's nothing wrong with my eyes. Or my heart. Under no circumstances should you be alone today. Monsieur Trabuc has Vincent occupied

in our home. He is painting a little mural on the wall of our upstairs guest room. You will not be disturbed."

We walked together back to the hospital. Already Monsieur Trabuc was sitting on the bench of his carriage, smoking his pipe. Madame waved at him and gave me a hug. "I am so very sorry for your loss, Emma. These days are terribly difficult. Try to imagine your little Camille in heaven, smiling down at you. Now go. Share your sorrow with someone who wishes to console you." She gave me a little push in the direction of her house and climbed into the carriage to sit next to her husband. I stood there looking down at the key in my hand, and then I obeyed her.

I have asked Vincent to accompany me to Paris, although I already knew his answer before I extended the invitation. He is painting fast and furiously these days—Outside! Like a man possessed. He is capturing on canvas the whole countryside. Olive orchards, olive harvests, cypresses, the entrance to a quarry. It seems that he has completely recovered his wits, his hand is steady, and he is working as

he must—a man on fire! It is a joy to behold, his fervor!

Though I sorely miss his company and our conversations during the day, I am content. Vincent is so happy in his work. We share short evenings together. Sitting very close on the settee in the drawing room, with no need to speak at all. I feel such tranquility of spirit when he is near. I would like to believe he feels the same soothing calm in my presence.

Vincent suspects that he will have another relapse within three months, and surely that lends an urgency to the diligence of his days. I do not want to trust his instinct, as I have faith that with better care, with love and attention, he might well be healthy for the rest of his long life. We shall see.

Dear Dominique, it would be utterly impossible for me to leave this hospital without reassuring myself that I will be with Vincent again, as soon as my circumstances allow.

In the meantime, I leave for Paris with the heaviest of hearts, though I will finally see you in a few days' time. Pray for me in my sadness. I send you my love and affection, Emma.

Arles

24 février 1890

Dear Dominique, I send off these last thoughts before I leave the hotel for the railway station. With this letter, one chapter of my life is ending while another, happier one, is waiting to be written.

I regret, sister, with the whole of my heart, that there continues to be such an awful rupture in our sisterly closeness. I do not remember that we have had such a violent collision of wills since that afternoon, so long ago, when we lived in London, and you broke my china tea set, cup by cup, because I refused to let you play with it. I pounced upon you like a tigress, and pulled your hair and bloodied your nose. I may have even bitten you.

While we will not come to blows over our current differences of opinion, today I am feeling as hurt and angered by your behavior

as I was as a four-year old, on my knees and crying over those shards of shattered porcelain scattered across the room while you stood above me laughing. You provoked me to violence, and then I cried for hurting you.

I do not cry today. I will not ask your forgiveness for leaving Paris, for leaving you, without warning. You know, as well as I do, that had I given any advance notice of my plans, you would have prevented my departure, and I could not allow you to do that.

Under the circumstances, it was vital to prepare my leave-taking secretly. I took very seriously your threats to commit me to another asylum, against my will and "by force if necessary." Don't my various precautions to escape your roof demonstrate that I still possess some faculty for reasoning? No, I am hardly ready for the madhouse. I have not lost my senses, Dominique, as you believe. I have, perhaps, lost only my naiveté—and my eagerness to please those who seem to have little regard for my feelings.

On countless occasions since last October, for four months, you and Henri have badgered

and harassed me with your disapproval, no, your "repugnance" towards my "sinful and obscene" conduct with "that demented degenerate." I tried to listen patiently, though your needless vilification of my character, and his, gutted me to the core. I wish that you and Henri had given my defense even half the courtesy and consideration with which I gave your views, as hurtful as they were to hear from the lips of my own sister, and interspersed as they were, with all manner of derogatory rants. It is said that it is not the snakebite that kills, but the venom. I know this to be true now.

You must cease your exhortations for me to "love wisely." Love wisely? By what measure do you propose that I should be judged as wisely loving, Dominique? Is that not how I have comported myself for the past twelve years in my relations with Edouard? Blissfully complying with Papa's designs for my life? "Wisely" following his and Edouard's advice and counsel, with love and blind devotion? Papa persuaded me that his handsome and ambitious clerk should be my suitor and then

my husband. I am certain that he had nothing but my best interests at heart. He wanted only to ensure a comfortable and secure future for me. It was I who allowed myself to be seduced by Edouard's flattery and his attentions, and by my need for Papa's approval.

I was young. I believed that I was loving wisely. During that year I was ten, within weeks of his introduction into our family, Edouard was caressing and petting me with greater ardor and gratification, with greater frequency, than during the entire two years of our marriage. It is a grave mistake, therefore, for you to attribute his diminishing interest in physical intimacy solely to my pregnancy and its horrific aftermath. The problem, or what I perceived as a problem, emerged almost immediately after our marriage vows. Yet, I endured it, with silence and shame, because I believed that by doing so, I was loving wisely.

From the day he first brought me to the asylum (weeks before Vincent's arrival), even the crazy old Madame Bondieu noticed Edouard's polite indifference.

I had not taken her into my confidence, Dominique. From witnessing Edouard's treatment of me during his occasional visits, Madame had sensed my marital difficulty. She held her tongue almost to the last, until the day in September when Edouard came down from Paris to inform me of his promotion and his impending move to London. While Marguerite played Chopin's *Nocturnes*, Madame Bondieu patted my hand. "*Bon courage*, my dear," she whispered. "Your husband is a *grand fouquit-ret*. I am an old woman with few prospects, but even I would not accept as much as a centime from that *patelin*."

Sometimes it is an observant stranger who sees what we, and even close family members, are either determined to ignore or loathe to accept. I spent almost eight months confined at St. Paul's, contemplating Edouard's treatment of me, both before and after Camille's birth, but most especially after her death. Edouard had been told by the doctor himself that significant events might provoke a relapse. On the first anniversary of Camille's birth, I waited, in vain, for a kind and

sympathetic message from him, my husband, Camille's father, but there was only silence from across La Manche. That is when my marriage finally ended, in that devastating quiet rolling through me like a thunderous wave, sweeping away the past and the future.

You must understand, Dominique, in no uncertain terms, that sooner, rather than later, I would have petitioned Edouard for a legal separation, regardless of anything that had, or had not, transpired with Vincent. If Vincent had rejected me yesterday or has second thoughts tomorrow, I should still be embarking on this path that I have chosen for myself.

Nor should you persist in blaming yourself for my "predicament." There is nothing you might have written last autumn that would have altered the events which eventually came to pass. I have come to believe that what occurred in the garden was ordained, from the very afternoon of my dream before Vincent's arrival until the moment it was consecrated with a kiss under a canopy of pine

and stars. As it is blessed now, with the new life growing inside me.

Papa often admonished that "Duty determines Destiny." But no! I have come to know, with absolute certainty: It is our Destiny which determines our duties. While you may be mortified by my actions, and vehemently denounce me for them, I am determined to follow the wisdom of my own heart and dreams. That is my first duty and my last, my sacred obligation. It is how we come to experience Grace. We have a duty to ourselves to be happy.

"It takes energy and willpower to conquer fate," Vincent tells me, but he is mistaken too. We do not "conquer" fate; we submit to it. With energy and willpower, yes. Fortunately, I have an abundance of both, and I will apply them with the same kind of inspired diligence with which Vincent devotes himself to his art. But passion and courage are also required. I am blessed with a wealth of passion. As for courage, it does not come naturally to me. But I will never overcome my fears if I do not make the attempt.

In light of my revelations when I left the asylum and returned to Paris, your willingness to remain in contact with Edouard is beyond all comprehension. It is a betrayal of biblical proportions—a modern Cain and Abel story, except that my murder has been metaphorical.

Yes, Dominique, of course I am well aware that you have continued your correspondence with Edouard. Your disloyalty breaks my heart, kills me with a thousand daggers. Be that as it may, you must surely know from his communications that Edouard is supporting my request for a separation with his customary charm and benign neglect. Is it not strange that you have had a stronger, more bitter and biting, reaction to my infidelity than he has expressed? Why should this be so? Unequivocally, I maintain: Because he has a greater preference ("a particular fondness," shall we call it?) for young girls rather than grown women.

You and Henri have dismissed my assertion as crazy and spiteful. You have accused me of exaggeration. You have rejected this truth of

my life outright, without serious thought to its merit. Believe what you will about me then, but I must emphasize and caution yet again: Monitor closely Edouard's contact with Louisa and Yvette. Already Louisa has great affection for her "Uncle Sugar" which makes her particularly susceptible to his dangerous charms. <u>Be on your guard</u>! Protect your daughters, as Maman and Papa did not protect me. As I did not protect myself when I was a young girl who thought she was loving wisely...

Vincent has been here with me these past two days. Within minutes of our long-awaited reunion, I felt the baby stir within me for the first time. For hours and hours, we lie, stretched across our bed, with either his hand or his ear pressed against my belly, both of us breathlessly waiting to feel again the thrill of new life quickening.

"The abomination," you call it; that is to say, the "unfortunate misbegotten abomination of a scandalous indiscretion." Never, never again, say such things about my child! Vincent and I, we created this dear new life with the purest of love, the greatest of passion,

and the rejoicing of grateful hearts. There can be nothing sinful or obscene in that.

Your fear that Vincent would desert me once he learned of my pregnancy was completely unfounded, as I knew it would be. In point of fact, when I delivered the happy news, he fairly exploded with whoops of delight and excitement, and he twirled me about the room. He became Uncle Vincent a few weeks ago; now he will also be Papa Vincent! No man, even Henri, has ever been happier to receive such good tidings, I assure you. He has already chosen names for the baby, Theo, after his brother if it is a boy and Tournesol if it is a girl. He has also discussed with me various ways to generate income, in addition to the sale of his art. He has even talked of returning to Paris to take up his old position at Goupil's at his former salary. Of course, I will not allow him to do any such a thing.

He brought happy news for me as well. Theo sold his *Red Vineyard*, to a Belgian woman, Anna Boch, for a tidy sum, 400 francs. He has been invited to exhibit his paintings in Brussels at *Les Vingt*, a distinguished art

society, and he will also be exhibiting this spring in Paris, at the *Salon des Indépendants*. This past January, the first volume of a new journal, *Le Mercure de France*, was published, with Vincent as its featured artist. The article, *Les Isolés*, by the respected art critic G-Albert Aurier, was devoted entirely to Vincent and his work. It was very complimentary in substance. I am sorry that I have just this one copy which Vincent gave me, otherwise I would gladly send you another. I strongly encourage you to read the whole of it.

Vincent is on the threshold of becoming, *enfin*, recognized as an artist of the first order, an artist's artist, although he is more humble in his opinion of himself than I am. He dismisses my optimism with a wave of his hand, as if he were wielding a sword. "Success is about the worst thing that can happen in an artist's life. He is punished for it with praise, which can be intoxicating."

"If you believe that to be true, then why do you labor so long and hard? Experiment with pigments and light? Struggle with developing your own unique style?" I did not give him

time to reply. "You must change your attitude about success, Vincent. You are painting for three now, and I do not intend that your child should go hungry."

"Don't be cross with me." He embraced me, then, and tilted up my chin to receive a soft kiss. A simple and spontaneous, rather ordinary gesture of affection, I should think. In fact, I did think that very thing, in that very moment. "How strange," I thought. "This must be what lovers do."

Do you know that I have not enjoyed that "simple gesture" since I was thirteen? Edouard was trying to cajole me into a new perversion that I had been resisting for months. I could be more graphic in my description of that awful afternoon which began so sweetly with an unexpected kiss, but you have not the stomach for it, sister. One man you deem to be a sinner, the other a saint. Which man is the true demon? Which man should I be "wise" in loving, Dominique?

Just as I am giving him the baby he has long desired, Vincent came to Arles bearing gifts for me too. He presented me with my

portrait, *La Croqueuse du Jardin*, he calls it, the one he completed last October *en plein air.* It is a remarkable piece, worthy of an empress, a veritable triumph of his talent and mastery of technique.

He surprised me with another painting too, a miniature, small enough to carry in my pocket. I will treasure it above every other material thing for the rest of my life. He had wrapped it in tissue paper and had tied a ribbon around it. The ribbon I recognized as one of my own. He had found it in the ivy last October, after I left the asylum. The painting is of a blue vase, the exact color of the tea gown I wore so often last summer. The blue vase is set against a pale yellow wall and over-flowing with deep pink roses. The very color of my cheeks, Vincent tells me, when I kissed his fingers in the garden.

"So you will never have to live without roses, dear Emma."

I laughed and wept at his understanding of me. Unlike Edouard, Vincent is a man of modest financial means but he is a man rich

in imagination and generous with his love and compassion.

"I painted it last July," he explained. "Before my attack. We'd gone for a stroll earlier in the afternoon." He remembers every detail of our walk that day, every word of our conversation while sitting on the stone bench in the wild part of the garden. He remembers everything as well as I do, even the blushes and sighs which I tried to conceal. He began to love me then. With Vincent, I shall have everything I need. How could it be otherwise? Even if my stomach is empty, my heart shall be full.

Why do I take the time to describe these private details? Especially since you have made it clear how repulsed you were by my letters of last autumn. To illustrate how severely you have misjudged Vincent, as an artist and a man. My sister Dominique, my older sister whom I knew and loved so well, had none of the snobbery, narrow-mindedness, and ignorance, which seems to plague you since my return to Paris. Do I even detect a hint of envy?

For all his excellent qualities as a loving father, Papa was a reactionary, and with all your talk recently about God and morals and protecting Society and Wealth, you seem to be following in his footsteps. This lack of empathy for others, especially those less fortunate than you, this appalling meanness of spirit does not become you.

I am Vincent's beloved, his "She and No Other," an appellation I welcome with love, gratitude and humility. Most emphatically, I am not, as you fear, the Camille Claudel to his Rodin. Or Rimbaud to his Verlaine. Or Sands to his ailing Chopin. We have no intention of scandalizing polite Parisian Society with unseemly behavior, with drunken rows or late-night shootings. Nor, too, do I have any plans to be his warden, caretaker or nurse. He will no longer require that kind of attention. He will have me, as I am, his Beloved. One has no need of curative baths when one is showered with kisses.

He is my dearest friend and my most cherished lover, my heart and soul's true and only husband. If my God has blessed

our union, and He has, then I fail to understand, Dominique, why you, mere mortal that you are, should have any objections to our seeking happiness together. Surely you cannot be that arrogant.

Yes, yes, I know. <u>Your</u> God does not countenance adultery. In His wrath, He shall smite me down and dispatch my soul directly to Hell. If that is the case, Dominique, then I must cheerfully remind you of Baudelaire's words:

> "What matters an eternity of damnation to someone who has found in one second the infinity of joy?"

With Vincent, I have known that joy.

Hereafter, if we are ever to be on speaking terms again, I forbid you to make disparaging remarks in my presence about Vincent's mental stability, his appearance, profession, or his ability to support me and our family.

Did not your God say, "Judge not, lest ye be judged?" In the New Testament? Matthew, I think. Consider that I am requiring you to practice a well-deserved, much-needed lesson

in Christian tolerance. Apart from his artistic genius, Vincent is the noblest, most loving, generous and compassionate of men. He deserves your highest esteem.

My solicitor has informed me that my pending purchase of property in St-Honoré can be finalized as soon as Edouard signs the papers for our legal separation and they are registered with the proper authorities.

Vincent left for St-Rémy this morning. He expects to complete three canvases and make arrangements to dispatch a <u>seventh</u> shipment of paintings to his brother Theo who is an art dealer in Paris, as you may remember from my references to him. Vincent will then join "us"—me and his "little angel of love" growing inside me. I expect that we will be settled into our home by the end of March. I have also invited Madame Bondieu and Margeruite Subileau to join us should they decide to leave St. Paul's.

I have not yet determined if I will seek an annulment of my marriage in the Church, which will be an expensive and lengthy process, or a divorce, or neither. I will leave

that decision until after I am settled into my new life.

In the meantime, when you are prepared to admit how cruel and unfair you have been in judging us, you may contact me in St-Honoré to apologize, and to beg our forgiveness.

I await profuse and sincere apologies from you, Emma

32, rue de la Paix
Paris
2 septembre 1890

My dear Emma, I am sending along this letter with Henri in the hope that you can be persuaded to return to Paris with him. Please, dear sister, for my sake, can we not set aside our disagreements, at least temporarily? With each and every one of my letters that you have returned to me, I have been robbed of sleep and peace of mind.

Worry for your health and safety consumes me, especially since Henri has been advised through contacts, though we have no confirmation, that earlier this summer you gave birth to a baby girl. Tournesol? Is that her name? We have also learned that your deranged artist is dead by his own unclean hand.

This past year has been, without doubt, an emotional time for both of us. If you must call

me a reactionary for wishing to protect you, your honor, your reputation and your property, then a reactionary I am, and proudly so.

For my part, I cannot, and will not, apologize for expressing my honest opinions about your lecherous hero-artist who, I continue to insist, took advantage of your trusting heart. You were mistaken to think that I would be as touched as you were by the pretty little details of your *rendez-vous* in Arles. If anything, they only confirmed how vulnerable you are to his artful persuasions and, yes, his machinations and manipulations. You do not know what schemes he harbored for your wealth and social position. A moot point now, for which I am grateful. Though I am sorry for the grief you must be experiencing, at least you will be spared the hurt and dishonor which would have befallen you in the months and years to come had you continued along the shameful path you have chosen.

Contrary to what you believe about yourself, you have lost little of your naiveté, Emma. You are still the child who collects stray animals as others girls collect dolls, and some of

those animals bite when you offer your hand to feed them. You are still the child who usually has her nose stuck so deeply within the pages of a work of fiction that she has not yet learned to distinguish the wheat from the chaff in this real world, peopled as it is, with those who would take unfair advantage and even do you harm, if you are not on guard.

At the risk of offending you yet again, it is here that I must return to that loathsome topic, the one which continues to divide us unnecessarily. I have every hope that your reason has returned, and you are able to think more clearly now that you are no longer pregnant and under the influence of that madman.

You are right in supposing that we have never had any secrets between us. I have honored my pledge, and I have expected you to do the same. If these vulgar acts you allege were actually being perpetrated against your innocence so long ago, surely you would have confided in me at least one time during all those years, or you would have displayed some small hint of your distress to me or Maman or Papa.

As it was, Edouard was kindness itself and you—you eagerly awaited his visits as if he were the handsome and dashing Prince Charming himself. Have you forgotten the shy schoolgirl you once were in his company? Though you feigned indifference, you always became flushed and fevered when told he would be joining us for dinner or accompanying us to the theater. You fiddled nervously with the buttons on your blouse in his presence, sucked on your braid, and you bit your nails too. You were barely able to lift your eyes from the floor when he spoke to you and you answered his questions in the softest of whispers, barely audible sometimes, so that often I would have to repeat your responses.

Do you wonder why my memory is so clear on these details? Because you became a different person when Edouard was near. It was an astonishing and maddening transformation. You became a sister I did not recognize, a sister whose whole composure was different from the real Emma I knew, the girl who argued loud and long with Papa over politics and poetry. And, how Papa enjoyed those

spirited debates! Sometimes he would take a contrary position just to bait you. He would praise your facility for words, and the impassioned reasoning of your arguments, and declare, aloud, that had you been a man, you would have made your fortune as an advocate in court.

But when Edouard joined us for lunch or dinner or a stroll through *Les Tuileries* or a ride around the *Bois de Boulogne*—why you were the epitome of bashful, blushing silence. To get Edouard's notice, I surmised, so that, out of courtesy, he would lavish his undivided attention upon you. As if you ever needed such a thing! I was infuriated by the cleverness of your deception, and enraged, too, because Edouard found your modesty so appealing.

Yes, in those days, I was jealous. It wasn't fair. I was the elder by four years; I should have had suitors first. When I met Henri, I quickly realized that you were not pretending to be someone else. You were being simply yourself: Little Emma In Love. And I forgave you.

Well then, poor Edouard got more than he bargained for, didn't he? Couldn't that explain, in part, your marital "problem"? He thought he would be getting himself a shy young wife with scarcely an audible opinion of her own, and certainly not one who had strong opinions and such an earthy appetite for sensual pleasures.

I can assure you that in all the years of your adolescence, there was never so much as a blink of impropriety in Edouard's behavior towards you in my presence or the presence of any member of our household, family or staff. Furthermore, as I recall, there was virtually never one single moment when you were alone with him, except that one time when he treated you to a *Montgolfier* balloon ride over Paris to celebrate your birthday.

How I envied you your adventure! To be sailing above Paris. Gliding across the cloud-streaked horizon, far above Notre Dame and *Les Invalides*. I stood at the launching pad in Montmartre, watching you rise off the ground, with one hand furiously waving back to you while tightly clutching Papa's hand with my

other. I held my breath and trembled for your safety even while I pouted and protested that I had not been invited to share the ride. Papa and I stood in the cold, watching until your balloon disappeared from our sight.

Yes, that is the one and only time I remember that you were alone with Edouard. You came home that night all happiness and smiles. Though the hour was late, you chattered on and on, with scarcely a pause for breath and with such unusual animation and hiccup-y giggles that Maman scolded Edouard for allowing you to become overly-stimulated. In turn, Papa scolded Maman for being such a spoilsport when it was still your birthday and she should be singing praises for your bravery and adventurous spirit instead.

"Our Emma has all the daring of Gambetta when he sailed over the Prussians in a balloon and escaped the Siege, and he was a Minister of the Republic!" How many times in subsequent years did we hear him repeat himself? Even when he toasted you at your wedding dinner!

I cannot accept that your chief reason for separating from Edouard is true, or is as compelling as you would have us believe, especially in light of what I witnessed with my own eyes and heard with my own ears at the time. After consulting with Dr. Peyron and a doctor here in Paris, we have been given to understand that it is more far more likely that these salacious "memories" you describe, and the accusations you make, are nothing more than depraved manifestations of your emotional affliction.

We have been told that, in all likelihood, you are suffering delusions, lascivious delusions wrought by your own shame and guilt—shame for debasing yourself in adultery and guilt over getting pregnant again too soon, before you were fully reconciled to poor Camille's death. Guilt, too, for allowing your prurient urges to take precedence over marital fidelity and maternal grief.

We read in the newspaper some weeks ago that your Vincent had died of a self-inflicted gunshot wound in Auvers-sur-Oise. According to the plan you conveyed to me by

letter last February, he was to join you in St Honoré-les-Bains by the end of March. It is useless for me to speculate why and how an alteration in your original plan developed. I do know there was no mention of you in his obituary. Why was this the case? Does it indicate that he had no genuine feelings for you after all? Or, that you were as delusional about his love and regard as you have been about Edouard's treatment of you in your youth?

Considering that you seem to be still in the grip of instability and turmoil, we are willing to suspend judgment as to the wisdom and morality of your actions. Nothing you have done, my dear Emma, is beyond our forgiveness. We love you without reservation, even when we have objected to your scandalous indiscretion, which is, let me remind you, every bit a reflection on us and our family, as it is upon you.

Last February, in the hurried letter you sent from Arles, you invoked one of Papa's favorite expressions: "Duty determines destiny". You wrote, then, that you have a duty to yourself to be happy with your life. Most

assuredly, Emma, Papa would revoke your entire inheritance and die a second death if he knew how selfishly you would misinterpret his words and spend his money on debaucheries. Yes, indeed, you have a duty to yourself, but certainly you have a greater duty to your husband to be a loving, faithful wife.

You even have a duty to me, and to your nieces and nephew. Gaston and Louisa miss you terribly, accustomed as they were to seeing you so often in the months preceding your abrupt departure. Almost nightly Gaston wonders aloud, after his prayers, if you have joined Papa and Maman in heaven since you disappeared so suddenly without saying goodbye to him. It breaks my heart when he questions me about your absence. As much as I try to make allowances for your illness, I resent how you are hurting my children, with such heartless disregard for their young and tender feelings. And what of our baby girls, so close in age, just as cousins should be? They should be growing up as happy playmates and the best of friends.

I will not even mention the extent to which I have been worrying over your physical health and the stability of your mind, and the toll it is taking on my own health, which has not been strong since Yvette's birth last December. My recovery has been very slow, hampered, no doubt, by my endless concern for your welfare and my own sadness at the breach in our warm affections.

I am sending with Henri a gift for your little Tournesol and a packet of letters, those you wrote to me last year from the asylum. Perhaps in re-reading them, your heart might be softened by how you once acknowledged my whole-hearted support during your illness, and I did support you, Emma.

You may discern, too, at this distance in time and in light of your changed circumstances, that your husband, though unintentionally neglectful, was only behaving as those men do who are ambitiously absorbed in making their careers successful for the sake of providing well for their wives and children. You may fault Edouard for many

things, but please, Emma, you must not blame him for that.

Can you not summon a measure of tender sympathy for his lapses in judgment? And mine? We all love imperfectly, Emma. Yes, even you.

You have endured great suffering this past year and a half, Emma. I cannot comprehend your reluctance to return to Paris, to return to those who love you. The little sister I knew and loved so well had none of the dangerous stubbornness which binds you to a course of action which seems foolhardy, at best. And, at the risk of offending you again, simply insane.

As Henri will explain, Edouard, ever the gentleman, stands ready to accept your child, if there is one, as his own. He will continue his life in London, and you may resume your life at *rue du Cherche-Midi*, as if this interlude of awful unpleasantness had never transpired. There is no good reason why you should allow yourself to endure the pains and travails of life in a distant village amidst strangers.

Please, Emma, I beg you to reconsider this treacherous path you are following. Do not

isolate yourself. We welcome you back with open arms and forgiving hearts. I urge you to return to Paris with Henri. In the event you choose to remain in St-Honoré, remember that we stand ready to provide help in whatever ways we may be of use. Do not hesitate to call upon us. Please do not allow your willful pride to compromise your own health and the safety and well-being of your daughter.

Your sister, who loves you still and always, Dominique.

[From Dr. Oosterkamp's contempora-
neous notes of 26 February, 2006]:

The early afternoon tea should have lasted
one hour, as I had originally scheduled. As
Madame Forcir, Rose, as she asked to be
called, moved in and out of the drawing room,
I conducted a cursory inspection of the phys-
ical qualities of the letters, a packet of thir-
teen, bound with a red velvet ribbon. I also
read them over quickly.

Initial Survey

The stationery and ink are in excellent con-
dition. The nature of the vellum paper fibers
and the black ink chemicals are consistent,
to the visible eye, with what we would expect
from this time period. All the letters; save
the last, dated 2 September, 1890; appear to
be in their original envelopes, with stamps

and postmarks consistent with their indicated content.

The handwriting of twelve letters is exquisitely elegant and clear, suggesting that the author was well-educated and enjoyed a privileged socio-economic status. Moreover, the letters are written in what seems to be fluent English, definitely not uncommon for a *bourgeoisie* Frenchwoman of this era, but certainly further evidence of education and elevated social status.

As to the substance of the letters themselves, I must defer to my learned colleagues who possess far more expertise in this field of analysis. I can attest, with some knowledge and authority, that many of the conversations Emma du Jardin attributes to van Gogh in these letters seem to echo familiar themes and specific ideas which he wrote about or expressed to others at various times in his life.

I most strenuously and heartily recommend that this collection of letters deserves immediate attention. I will explain the

authentication process to Madame Forcir, and we will proceed according to her wishes.

THE REAL TREASURE

I was pacing the room, in the middle of a sentence, about to ask permission to take the letters back to Amsterdam with me, when, inexplicably and impolitely, I turned my head away from Madame for an instant. Out of the corner of my eye, just beyond the threshold to the dining room, I spotted a large oil painting, hanging over the mahogany sideboard.

The sight propelled me out of the room. I moved quickly to examine the piece more closely. There, on the wall, in a plain oak frame, the kind favored by van Gogh, a beautiful young woman was reclining in the splendor of silvery green ivy, nude, her skin pale and luminous under a starry dark blue night sky, her smile tender and inviting. I was, quite literally, struck dumb with awe.

The elderly woman followed me into the room. "My grandmother," she said, with a smile. "The painting is *La Croqueuse du*

Jardin. She is the woman who wrote the letters you have just examined."

My heart beat wildly and I could feel blood rushing to my face. I could scarcely contain my excitement. I could not turn my eyes away from the canvas. "*La Croqueuse?*"

"Yes. It was a pet name given to her in the asylum. *La Croqueuse des fleurs*. Flower Eater. Or, to be more precise, Flower Devourer." Rose laughed. "She had a fondness for eating flowers, you see. Especially roses. It was part of her madness, they said."

The painting was unsigned, but I had every reason to believe that it was an authentic work of Vincent van Gogh. At that moment I might have argued that it is his masterpiece, a culmination of his long artistic apprenticeship. With a brilliant blend of color, light and shadow, agitated lines and calming composition, he had captured a dramatic and breathtaking tension of opposites: a blissful restlessness or a restless bliss. An innocent eroticism or an erotic innocence. Its immediate effect on the viewer, on me, was profound and electrifying.

"Would you mind, Rose, if I take up a little more of your time to make some notes about the painting too?"

For a full ten minutes after Rose left the room, I sat and allowed my eyes to graze freely upon the extraordinary portrait. I realized, then, that I was woefully unprepared for my fateful *rendezvous* with *La Croqueuse*. I had left my digital camera and my laptop back at the hotel in Paris; my tape recorder was still in Amsterdam, somewhere in my office. I opened my notebook and jotted down the following first impressions:

1. The background of the painting is similar to others van Gogh painted at the asylum in Saint-Rémy, depicting a stone bench in a wild garden.
2. It was at this time in his career that Vincent was wanting to do more portraiture.
3. It was not unusual for Vincent to neglect to sign the paintings he completed while at the asylum. Of the some

150 oil paintings he produced there, only seven were signed.

4. There has always been talk of missing paintings, dating from this period of van Gogh's life. We know, for instance, that the original portraits of the Chief Warder Trabuc and that of his wife are missing. They were given to the couple who had befriended him, and all that remains to posterity are the smaller copies that Vincent painted for his brother.

5. In a letter to his brother, van Gogh refers to working on a portrait of a patient for which he gives no further information. This was highly unusual for him. Ordinarily, in his letters to Theo, his mother and sisters, and to various friends and professional colleagues, he discussed in great detail his current projects. Sometimes he included sketches with his written descriptions.

6. We know that in February 1890, Vincent left the hospital for Arles with a large oil painting. When he did not return at

the appointed time two days later, Dr. Peyron dispatched two attendants to find him. He was brought back to the asylum, incoherent, recognizing no one, not knowing where he had spent his time in Arles, and without his painting.

For all these reasons, and as this packet of letters seems to confirm, it is more probable than not that *La Croqueuse du Jardin* is a genuine van Gogh. A major discovery in the art world. Perhaps the first great finding of the twenty-first century.

On the side of caution, however, there is a plethora of documentation relating to van Gogh's life and his work. To my knowledge, nowhere among the papers, nor in his extensive correspondence with his brother, is there any mention of an Emma du Jardin or *La Croqueuse du Jardin*. There was a M. du Jardin, I believe, who tried to arrange an exhibit of his work, but Vincent declined the offer because its terms were unacceptable.

Furthermore, in the definitive catalog of his work, there are no sketches of a nude, or half

nude, studio model dating from that period in his life, as the letter dated 14 September suggested there might be. Nor, as far as we know, was an oil portrait *à la Grande Odalisque* ever executed from these sketches. This was an extremely prolific time in Vincent's life and it seems unusual that when the weather turned rainy, he would not have returned to the referenced sketches to produce oil portraits in his studio, especially in light of his complaints that he had no models. Unless, as was often the case, he was running out of canvas and paints.

The portrait itself, however, hanging directly across the room, will be the incontrovertible evidence. It far outweighs these flimsy reservations. In my mind, I am already generating a list of experts who would be invited to participate in the authentication process. I am calculating how much time will be required and I am mentally clearing my calendar to spend the next few months in this little village. I could be back in Saint-Honoré within a week's time to dedicate myself exclusively to this project.

I tried to explained my excitement to my hostess. "This collection of letters that you've shown me seems to substantiate your painting's authenticity, and they also provide unique insight into the whole of its creation, from the rare perspective of the painting's model."

Rose was perfectly calm and composed, smiling. She seemed almost confused at my enthusiastic reaction. "This portrait of my grandmother has remained in that very spot since the day she brought it here and hung it on the wall in 1890. I have always known it was painted by a man named Vincent. He was my grandmother's dearest friend, her *copain*. Though I never met him, I think he died before I was born, she spoke to him all the time when she thought no one was watching her laugh and talk to the air."

We sat down at the dining room table. I described again the Foundation's strict process of authenticating both the portrait and the letters. I tried to maintain a professional demeanor, but I know my voice must have betrayed excitement and utter amazement.

"Didn't I read in one of the last letters that there was another painting, too? A miniature of blooming roses in a vase?"

"Oh yes. There was that pretty little painting. She kept it by her bed. She used to say, 'I cannot live without my roses, and I don't intend to die without them either.' I am told she was buried with that little painting in her hands. Some women clutch rosaries in their graves; my grandmother clasps her roses."

She seemed to blossom, then, and eagerly began talking about her grandmother. "My grandmother always told me to expect the arrival of a Dutchman. She predicted that he would change my life as another Dutchman had once and forever altered the course of her life. I did not know that I would be so old or that I would have to wait so long." She laughed, then, like a young girl. 'But here you are! *Bienvenue!*"

Madame Emma du Jardin bought the boardinghouse in St-Honoré sometime during the spring of 1890 and took in pregnant unmarried women until her death in 1945.

Her daughter, Tournesol, Rose's mother, was born on 1 August, 1890, a few days after van Gogh died of his gunshot wound, which Rose did not know until I informed her.

"Tournesol is the French word for sunflower, you know."

I nodded. We both sat utterly still, silent, gazing at the lovely young woman in front of us.

"May I offer you a *kir?*"

I quickly accepted her invitation.

"From what I understand, although I've never checked official records, my grandmother and her husband never divorced. He lived and worked in London until his death of influenza in 1918, before I was born.

"I have reason to believe that Vincent van Gogh, not Edouard du Jardin, is my grandfather. I am certain that you will draw the same conclusion after studying the letters."

"There are DNA tests..."

Rose interrupted me with a wave of her hand. "I am an old woman, Julius, childless and alone. I have no need of proof. It has been my grandmother's secret for more than a hundred years. I have no wish to upset the

apple cart. It is enough that I know. The notoriety would probably kill me." She laughed. "My grandmother was quite adept at keeping secrets. She and my mother both worked for the French Resistance throughout WWII. They used this house to hide Allied airmen whose planes had crashed until they could be smuggled out of France. They had some other 'crazy little adventures,' as they called their war effort. I have been told that my grandmother used *La Croqueuse* as her code name. "

We both gazed up at her grandmother who smiled down upon us. Yes, one might easily read in her face that Emma du Jardin could be a woman who might have many happy secrets. In spite of her delicate beauty though, there was something about the tilt of her head and a spark in her eyes which suggested that she was a woman who could also keep dangerous secrets. Even if tortured.

But, then, I had to remind myself that by the 1940's, Emma would have aged more than fifty years from the time Vincent had seen her. Painted her. Loved her, perhaps.

"My grandmother did some translation work for the Germans, and she passed along tidbits of useful information to her 'comrades,' so to speak. The excavation which unearthed her letters, also turned up jars of clippings from local and regional newspapers, and bulletins from resistance presses all over France. She was quite the collector. I imagine the two of them, my mother and grandmother, in the garden with their shovels, hiding evidence of their subversion. Judging from the number of bottles and jars the workmen found, they were very busy."

"And you? You sound as if you weren't here during the war. How old were you, Rose? How did you survive the war years?"

"Well, now, that was once my little secret." Rose shook her head and laughed.

"My older brothers enlisted as soon as Poland fell. It must have been sometime in the fall of '39, soon after Grace, a pregnant American refugee from the Spanish Civil War, found our house. The night they left, my grandmother had horrific nightmares which woke the whole house with her screams. When

I came down to breakfast the next morning, I still remember them, my mother and grandmother, sitting at the kitchen table, with their coffee and croissants. My mother looked up at me and said, 'She has had another dream.'

"She turned back to my grandmother and they began to discuss what should be done with me. I was seventeen at the time, and they sat there talking about my future, with scarcely a nod in my direction. They were both adamant that I be sent out of harm's way, and Grace was anxious to get back to Chicago with her baby who was born a few months later. She named him Paul in tribute to my brother who insisted she get to our home in France where she could deliver her child in a loving home.

"Through Grace's contacts, my grandmother made arrangements for me to teach French in the States. They purchased rail tickets to Bordeaux, where we were to board ship, and three one-way tickets to cross the Atlantic.

"They put us on the train on the 13th of April, 1940. To safety, they thought. By the

time we arrived at *Gare de Lyon* in Paris to change trains for the west, I had already decided that it wasn't fair that my brothers should be allowed to fight the Germans while I had to teach passé composé forms to bored American school children. At first, Grace tried to discourage me with her own horror stories about fighting in the trenches in Spain, about her experience in Guernica on the afternoon of the bombing while they were trying to make their way out of Spain, away from war, but how the massacre and the fire renewed their vow to fight fascism. I headed straight for *Gare du Nord* and exchanged my rail ticket for Calais. From there I went to London. Just three weeks later, Germany broke through the Ardennes and by the twenty-second of June, France had fallen. Because of my grandmother's dream, they got me out just in time, when it was still relatively easy to travel.

"I did not make it back to France in time to see her again. My grandmother died the day the war ended in Europe, the eighth of May, 1945. If you look behind you, you'll see the medals she was awarded, posthumously. *La*

Croix de Guerre, in 1947, is in the middle. The *Legion of Honor,* on the right and the *Médaille combatant de la Résistance* is on the left.

"If there was any blessing in her death, it was that she never learned that my brothers had been killed. They both died very early in the war, in Modane, at the Belgium border. She had an inkling of the Nazi death camps, I know, but I do not think she was aware of the utterly incomprehensible scale of the killing. She did not know about Hiroshima. Nagasaki. She was, at least, spared those horrors.

"Forgive me, Julius, I chatter on and on about my life which is not at all why you are here."

"I don't mind at all, Rose. I enjoy hearing such stories."

"Another *kir*, then?"

I looked at my watch. It was late in the afternoon, and I had planned a dinner with friends in Paris. "I appreciate your offer, but I have a dinner engagement in Paris tonight and then an early flight back to Amsterdam in the morning. In fact, I should be leaving soon."

"Oh yes, of course. How thoughtless I am. Please forgive my chatter, Julius. I've always promised myself that I would never become one of those old women who can't stop talking to save her life, but here I am forgetting my own promises."

I suddenly recognized that she had the smile of her grandmother. Why hadn't I noticed the unmistakable similarity earlier? "Forgive you? I've been having the one of the most interesting afternoons of my life. As I explained earlier, I plan on returning to St-Honoré as soon as I can clear my calendar. Perhaps as early as next week.

"I'd like to bring my tape recorder with me, if you don't mind. To record these memories you have of your grandmother and mother. There may even be a book here. Perhaps we might be able to collaborate..."

"Collaborate? That's a dirty word in this house!" She leaned closer to me. "I suspect my grandmother and my mother may have even *killed* some collaborators."

"Killed collaborators? *La Croqueuse*? *Vraiment*?"

Rose nodded her head without turning her eyes away from her grandmother's portrait. "It's just a feeling I have, you understand. But I thought I've read some allusions to it in letters she wrote. And some of the newspaper clippings that were sealed in the jelly jars... They report specific incidents of people found murdered. It's a very strange thing to bury in a garden, *n'est-ce que pas?*"

She looked at me then. "I hope you'll have time someday to look over all this other material. It would be helpful to have a second pair of eyes. Another opinion. Who knows if I am allowing my imagination to run wild."

She stood up. "I am going to have myself another *kir*, and like it or not, I am not going to drink alone, young man."

Rose kept talking as she went into the kitchen and returned with our refilled glasses. "She kept a journal, you know. Besides the letters, she kept a journal of her time in the asylum with van Gogh. She gave it to me. " 'A small gift,' she called it. "

I'll admit, I almost fell off my chair. "*La Croqueuse* kept a journal? Besides the letters? Good God, Rose, have you read it?"

"I have never been able to find that journal. It was not where she wrote that it would be hidden. I've never been able to find any of her other journals either. I watched her fill those pages all my life, until I left France."

Rose spread St. Augur on two slices of baguette and handed one to me. She brought her piece to her lips, but held it there, as if she were deciding whether to eat or to speak. She put it back down on her plate.

"I suspect my mother destroyed all Emma's journals before I returned home after the war. I don't know if she was trying to protect my grandmother, herself or me. Or, if she was in the grip of a breakdown. I was angry with her for years.

"To her dying day, though, she denied destroying them. I continued looking. I never thought of digging up the garden though. But, of course, with all the bottles and jars that the workmen dug up, I've been given new hope.

They might have missed something. The journals. Other letters."

"Could it be that the early journal she kept at the asylum never existed?"

"No. It existed. I am certain of that." She dropped her hands into her lap and bent her head. For a moment, I wondered if she was dozing off from the effect of the *kirs* before dinner.

"Rose? Madame Forcir?"

She lifted her head, then, and reached for my hands, clasping them tightly. "I have one last letter that I have not shared with you, Julius. It doesn't really belong with the others. It is addressed to me, fifty-five years after my grandmother left the asylum. My mother did give me this one letter when I came home. There should have been five birthday letters waiting for me. What happened to the others, I do not know. But I know my grandmother wrote them, and they were gone when I returned. They are in the garden too, perhaps.

"This letter, these are my grandmother's last words to me. I don't want you to take this letter with you, but if you would like to

read it while you are here now, I'll allow you to look at it. If you determine that it adds to your research, I will make a copy and you may use it however you wish."

Outside, it was already dark, and I could feel a strong cold wind whistling through the walls and chilling the air. I knew that I would be thinking of that one last letter all the long way back to Amsterdam if I didn't stay and read it that very night.

Rose must have sensed my hesitation. "Why don't you light a fire, dear, while I get my letter. The logs are already in the fireplace. The matches are on the mantle, and the kindling is in that basket over there."

Rose returned before I had a chance to strike the first match. She set the letter down on the table beside the sofa. "Go ahead and read. In the meantime, I'll be in the kitchen making you an omelet. My grandmother would be appalled if I failed to fill your stomach before you left."

I relaxed into the comfortable sofa and turned on the lamp. Unlike the letters I had read earlier in the day, the handwritten ones

which had survived more than fifty years in jelly jars buried under the soil, these pages were typewritten on onion-skin paper and dog-eared, folded and re-folded, stained with what—coffee rings (?), smears of red wine (?), smudges (tears?). The letter apparently had been read and re-read many times over the years. The room was already becoming cozy warm. I turned off the lamp to read by firelight.

Saint-Honoré-les-Bains

15 août 1944

Ma chérie belle Rose,

Today is the twenty-second anniversary of your birth, and the twenty-third letter I have written to you to honor this special occasion. This letter will be different from all the others for many reasons. The first you have noticed already. Yes, this year I am reluctantly using my typewriter. I have always preferred to write out these birthday letters. To move my hand across the lovely vellum paper and enjoy the weight of my favorite pen and the smooth flow of its ink as it commits words and meaning to a blank page. It seems a more intimate and pleasing manner of conveying my thoughts. But your grandmother is older today, just as you are, dear, and my arthritic fingers get cramped easily these days.

This year, too, I may not be here to hand your birthday letter to you as I have passed

such letters across the table before you ate breakfast, watching your lovely face, hearing your chuckles, and sharing a cozy chat afterwards. Another ordinary family tradition trampled by the whims of war.

It is also the first year that I am writing your birthday letter without hearing Marguerite's music echoing through me. This past year we surrendered our dear friend to eternity. She died quietly in her sleep. How we miss her concerts on these long summer evenings. Radio broadcasts, even the symphonies, cannot compare to the pleasure we derived from her music. With her eyesight failing and her fingers, swollen and twisted by arthritis, she retained, until the very end, her abiding love and passion for playing the piano. It became humbling to watch her play, when she must have been in such excruciating pain that my own fingers ached to hear the chords.

On the day before she died, Marguerite played from dawn until dark, fifteen hours, with scarcely a break. Though we urged her to rest, our entreaties fell on deaf ears. She refused to be stopped, perhaps sensing that

she was about to be silenced forever. She finished her recital with a most stirring rendition of *Le Marseillaise* that I have ever been privileged to hear. She gave us renewed hope for France that we hold in our hearts still.

In many other ways, some quite laughable, I find myself submitting more often than not to the inevitable vagaries of age. With this letter in your hands, you will be holding yet another symbol of my capitulation to advancing time, but it is only a small surrender, after all. I take comfort in that. Other sacrifices have caused much greater indignation and inconvenience, and required far more courage.

Within the hour of your first breath, and every subsequent year, I have started my annual birthday letter to you with a recounting of your arrival into this world. How you greeted us with strong lusty wails, your blue eyes wide open, your head turning toward the open window, and your tiny fingers stretching to tickle the air.

"My God," I announced that morning, "She is going to be a pianist!" From downstairs, at that very moment, we could hear

Marguerite begin to play a medley of lullabies. You stopped crying instantly and turned your eyes towards the door, as if responding to the melodies. I thought I caught a glimpse of your lips curling into a smile of appreciation. Or, perhaps it was recognition, since you seemed to possess, from a very young age, an innate gift for singing and playing the piano. But it just as easily could have been gas.

It is at this point, every year in the retelling, that I pause. Sometimes a sigh or two gets the better of me. I have not previously mentioned this moment of sad reflection, this moment when I am reminded, yet again, that I cannot recall the birth of your mother as well as I remember yours or that of my other grand-children. I had reasons for forgetfulness, to be sure; my labor was long and hard, and the months preceding Tournesol's birth had been fraught with disappointment and disquietude. Even so, it is a bit troubling that I was not as mindful as I should have been, no, as mindful as I wanted to be. That first moment of wel-come into the world is so important. One is able to see the arriving new soul so clearly.

There! I have had my sting of regret, and shared it.

For weeks now, as I walked into the village or collected lettuce and tomatoes and cucumbers from the garden, I have reflected on what I would write in this letter. I seem to lose my focus easily these days. I did not have this problem when I was writing birthday letters to your brothers, but you, Rose, you are a young woman. Too often these days, I find myself slipping back to myself when I was twenty-two, preoccupied with re-collecting that year, 1889, in all its fullness. Apart from the year of my own birth, I believe it was the most significant time of my life. I wonder if your twenty-second year will prove to be as important to you, a time when you will discover within yourself a reserve of strength and resilience to endure the unendurable. Your mother was conceived that year, and she has been the blessing of my life, a lovely and living reminder of every good thing in this world.

It was an unbearably wretched, but unexpectedly wonderful, year for me then, some fifty-five years ago, when the course of my

life was suddenly and forever transformed in ways I could not possibly have anticipated nor adequately prepared myself to accept with any semblance of grace and good humor. The death of my father, the birth and death of my precious baby Camille; the complete collapse of my senses; confinement in a far away asylum; the separation from my husband; the discovery of love, the deep and mysterious kind which transcends all; and the rift with my sister, your Great-Aunt Dominique. Mid-way through the year, I began chronicling those times in a journal. You are old enough now, I believe, to read it. You will find it in the old trunk in the attic, nestled among folds of lace from dear Camille's Christening gown.

I regard my portrait in the dining room, *La Croqueuse du Jardin*, another souvenir from my twenty-second year, though I prefer to call it, *La Belle au Bois Dormant, Sleeping Beauty*, and marvel at that young woman who had such determined untested faith in herself. Most certainly there was that night in early October, there was that night a magical kiss that awakened me to my real life. It was the

eve of my twenty-third birthday, and there was that night more than enough love to forever heal mankind from its hatred and woes.

And here we are, more than half a century later, suffering through yet another worldwide war. This one even more horrendous than the last, though such a state seems scarcely imaginable.

When I was twenty-two, we had few of the conveniences we possess today: everywhere now there is electricity which illuminates our homes more safely than candles and gaslight. Telephones and automobiles and aeroplanes and radios and electric Singer sewing machines and phonographs and moving pictures and vacuum cleaners...the list goes on. I daresay that during my lifetime, there have been more technological advances than the whole of civilization has seen since the very beginning of time. I cannot but wonder if you, my dear young Rose, will also witness a similar flurry of inventions which will make your life easier and make this wide world seem smaller, and perhaps, safer.

And yet, for all our recent marvels and our mastery over the mysterious laws of science and nature, mankind seems as dumb and bellicose as the most primitive caveman when it comes to living in peace and harmony with our neighbors, near and far.

At least the cave dwellers in Lascaux had their art. I sometimes wonder what compelled them to create it? Passion? Spiritual need? Boredom? What purpose did it serve to take such extraordinary efforts? Were they invoking great animal spirits for good hunting? Creating sacred space? Did they find some measure of peace in their creations?

Why does it seem that we have learned so little from twenty centuries of "modern" life? Is this not a plague of epic proportions?

I am ashamed to confess that even I have not been immune to this disease. My hands are not clean, Rose. We, your mother and I, have not been mere armchair resisters, drawing the shades and listening to BBC radio in secret or turning our backs when a parade of German soldiers marches past.

In war, all things are possible. When one's very survival seems threatened, it is not difficult to choose hate over love. *En effet*, it is all too easy, which is the most frightening lesson I have learned in my entire life, believe me. I have seen hearts far purer than mine corrupted by war. It always surprises me. No, I should not use the word "surprised". Surprise suggests something pleasant. I have been shocked. Sometimes even traumatized, as when I hear from our friends in the East, rumors of unspeakable crimes which defy our capacity to comprehend.

Oh, that I could have found a cure for war and intolerance, if only within myself! It would have been a legacy most worthy of passing down to you, my beloved young Rose, who deserves, as all children do, a kinder world in which to grow and thrive.

When I was twenty-two, I could not conceive of a world at war; the sudden death of my innocent infant daughter was enough to catapult me into an abyss of grief, just where I fell again in 1939 when your brother Paul died in Teruel, fighting the fascists in Spain

while most of the world stood by, silent, busy in their business busyness. At least I was able to take small comfort that my strong, idealistic grandson died for a worthy cause.

More than forty years separated the death of my daughter and the death of my precious grandson; it was no easier when I was seventy-one than when I was twenty-two, though I was more practiced in handling grief and loss. Whoever would willingly "practice" such experiences?

While mourning Paul's death and trying to soothe grieving Grace through her misery, I remembered some words of comfort my dearest friend had imparted when I was still grieving the death of my baby. "You may be old or young," he said, "but there will always be a moment when you lose your head."

You must not be afraid of these times, Rose, when they come upon you, and they will, if you are living your life with love and truth and passion. Banish all feelings of shame and powerlessness from your mind. Be gentle with yourself, dear, and patient. In time, even if it is a very long time, you will heal.

Your strength, you see, comes as a consequence of your grief. Once you have suffered the very worst, the very deepest of sorrows, the unexpected death of your baby or the cataclysmic loss of your beloved, well, then, nothing that happens can ever wound you quite as much.

At night I hear the moans and cries of millions of women, weeping for their husbands and lovers, sons and daughters, sisters and brothers, mothers and fathers, aunts and uncles and cousins and friends. They weep for themselves, too, as we women do, when peace seems only a dim dream, far beyond any hope of realization. Until, finally, we are willing to acknowledge the transparent obvious: that wringing our hands and weeping is no defense against endless fear and worry, and profound loneliness. Only then do our tears have power. The salty hot tears wash away our anger and hate until what remains is only the essential: Love, and the memory of love, and the hope for love's return. Destiny is uncompromising in its perfection.

You will read this in my journal, but I am not embarrassed to repeat myself. What's the advantage to aging if I can't indulge my memories as soon as they come to mind?

I was twenty-three when I came to St-Honoré, by way of Arles. I was young and pregnant and happy, brimming with love and fairly bursting with joy. My dearest friend was supposed to meet me there within the month. He did not come. And still he did not come, and he did not write nor did he send word through his brother. A year earlier, I might have gone crazy with grief at his unexplained absence, but I had learned to find solace in poetry. In one of those serendipitous moments, laced with divinity, I read these words of William Wordsworth:

> There is comfort in the strength of love;
> 'Twill make a thing endurable, which else
> Would overset the brain, or break the heart.

The strength of love. That is what saved me then. It saves me still.

I did not know of my dear friend's sudden and tragic passing until weeks after your mother was born. I learned it when my brother-in-law, your Great-Uncle Henri, came to take me back to Paris. I refused to go with him, and I have never once regretted my decision to remain here.

My mother's favorite bromide was "It is better to give in than to give up." I am certain that such advice served her well enough. She was a woman possessed of a calm, even temperament, and such regal bearing that she was not required to "give in" very often, I assure you. To the contrary, I have found that sometimes it is necessary to give up. Do not castigate yourself, dear, for your seeming lack of love, devotion, persistence or stamina, if you ever find that you must walk away from a decision you have made. There are others who will punish you enough for following your soul's imperative.

But then, there are also times when you must fight. Here we have been, living *sous la botte*, because our leaders thought it wise to give in to the Nazis. Give in <u>and</u> give up.

"Better Hitler than Blum," too many said and too many more believed. How willing they were to accept the words of Maréchal Pétain, that decrepit war hero of the Verdun, who assured them that with the armistice with Germany, French blood would be spared and France could re-dedicate itself to "Work, Family and Fatherland." Too late, the French people realized that they had been duped.

So you see, Rose, there may be other times when you will be required to fight, to fight long and hard and with great sacrifice. How I wish that I could point to a book on a shelf and say, There is the manual, Rose, the manual which will instruct you on how and when to make distinctions. How to determine when it is "right" to give in or give up or stand firm and fight.

The great secret is this: You already possess the wisdom you require, Rose. Let your wisdom unfold and blossom, in its own time. Trust yourself, dear. Love easily. Love fearlessly. Love as if your life depends upon it, because it does. Be honest and kind. Laugh often. Celebrate passion and practice it

fiercely, joyfully, with the whole of your heart and soul. Forgive quickly. Cultivate courage. Honor your strengths. Fortify your perceived weaknesses, for there you will find your truest treasures.

And finally, ignore this list of mine in favor of your own. Every generation must find its own way. You will have no easy task, given the state of the world today, but I have to trust, and trust does come more easily with age, that your mother and I have prepared you well enough. At least that is what we intended.

Please forgive my rambling today, dear, and my grumbling. I have been avoiding sharing these last thoughts with you. For months, I have been experiencing a series of particularly disturbing nightmares. Perhaps as far back as last June, coincident with the long-awaited Allied assault in Normandy.

The dreams began vaguely. At first, I was waking with no specific images, but only a terrible sense of dread, breathless and chilled, with my pillow soaked with tears.

Over the following nights and sometimes afternoon naps, the dreams became clearer,

more defined. I was being pulled toward a large inflated *Montgolfière*. After some nights, the dream continued further. I was being pulled, and then I was being thrown headfirst onto the floor of its wicker gondola, and held down by smooth, brutal hands which pressed on my wrists with such force that I feared my bones would snap.

As nights passed, I stayed asleep long enough to experience the balloon rising off the ground, though I had no means to control its ascent or descent. For several weeks, my nightmares would end there, the basket swaying violently though there was no wind, panic rising from my toes to my throat, even as the balloon was climbing faster and faster and then exploding into a dark void.

When I have opened my eyes from these nightmares, my fingernails have been curled so tightly into my palms that they are bleeding and the sensation of tumbling down into blackness remains. On some mornings I have deliberately kept my eyes shut to see what happens next. But it is always the same—a startled, frightening long free fall into the

blackest black. Sometimes it has taken me as long as ten minutes to recognize my own bedroom after I have opened my eyes.

An old woman dreaming of hot-air balloon rides? It is not so far-fetched, you know. Throughout my childhood, I heard countless stories of the Siege of Paris, though we were living in London at the time of the Franco-Prussian war and the civil war which followed. As you may remember from your history lessons, the Prussians had Paris surrounded and had taken over Versailles entirely. In the Hall of Mirrors, King Wilhelm I proclaimed himself Emperor of the German Empire.

The French government escaped to Tours. As the siege continued and all the sheep grazing in the *Bois de Boulogne* had been eaten, the zoo provided meat (only the lions and tigers and monkeys were spared). While Parisians dined on camels and kangaroos, and made subtle distinctions between the taste of brewery rats and common Seine rats, white cats and black, it was hot-air balloons which saved the nation.

First, there was the flight of Gambetta, our Minister of the Interior, who escaped the besieged city by means of a balloon, the *Armand Bargés.* How his feat lifted France's morale when he landed safely at Tours! With his success, and that of a few others, the Balloon Post was initiated. Balloons were manufactured in the empty rail stations, and provided essential communication with the rest of France. Under cover of darkness, millions of letters flew out of Paris while the Prussians, who so smugly held our city hostage, could do next to nothing.

I went for a hot-air balloon ride only one time in my life. Survived it, would be a more apt description. Edouard, the man who was to become my husband nine years later, took me up as a present to celebrate my eleventh birthday. How fervently I argued with my father against accepting his gift. No amount of tears and pleading worked. Even when I argued that one of the mail balloons had left Paris for Tours and landed in Norway. "I don't want to go to Norway, Papa. Please don't make me."

My father waved off my concerns, harshly. He could be very stern in his stubborness. "Nonsense. That was years ago, Emma, during the siege. Advancements have been made since then. Pilots have better control these days. Edouard has been thinking of your gift for months. And what a unique idea he has had. You would repay his kindness and ingenuity with a refusal? What kind of ungrateful daughter have I raised?" He shook his head and left the room. He did not speak to me for the rest of the day, and by bedtime, I had decided I would go on the balloon ride, after all.

It was pleasant enough, at the start, after the first few violent jerks. Dominique stood below me with a scowl on her face. That pleasure alone made my fear shrink. But then we kept rising, and a gust of wind jerked us up higher and higher until I could no longer see her anger. Then I couldn't see her at all. I began feeling dizzy and sick. My last thought before I fainted was "Dominique will be envious forever!"

I remember nothing else of my balloon ride or the landing, or being lifted from its wicker gondola and transported to the carriage which took us back to Paris. Dominique was still frowning when I returned home.

But now, night after night, your grandmother dreams of sailing in a hot-air balloon! I have come to realize, dear child, that these dreams, most probably, herald my approaching death.

My dearest friend once confided that "he was more ambitious for the graveyard than a throne." I thought at the time (again, I was twenty-two) that it was a rather macabre view of life (or death) for a man of thirty-six who was so close to realizing his passionate dream of a successful career as an artist, a man who had recently found, *enfin*, a woman's love, a love he reciprocated joyfully, with such touching tenderness and gratitude.

This is where I find myself today, on your twenty-second birthday: "more ambitious for death than a throne". These dreams have been my own peculiar way of preparing myself for the inevitable, I suppose. Now that

I understand their meaning, I am no longer distressed. I am, in fact, curiously eager at the prospect of experiencing the penultimate mystery of life. I never could resist a good mystery!

Please, you must not grieve too much if I am not in the garden or in front of the fireplace as you read this letter. Picture me, Rose, your old grandmother, laughing and waving to you, with my head turned upward, my long white hair floating freely, wildly, as I slowly rise, taking death to reach the brightest, most brilliant twinkling star in all the heavens.

Above all: Know, as I do, with absolute, irrefutable certainty: Love is stronger than death. My dearest friend once said that "painting harnesses infinity." But I have had the advantage of living far longer than he did. And I know that Infinity is harnessed by Love.

À Dieu, my sweet Rose. I leave you with love, Infinite Love.

P.S. Have I ever written a letter in which I did not have an afterthought or two? This one is no exception. Apparently I still have lessons to learn, yes, even at my advanced

age! I have reminded your mother a dozen times, and I've written it down somewhere that I can't recall at the moment, that she must give you my volume of Walt Whitman's poems. It rests with my journal in Camille's Christening gown. It was a gift given to me by my dearest friend on the morning I left St. Paul's asylum in late October, 1889.

"To occupy yourself," he said. "It is a long train ride to Paris." I first read it, with my tears falling on every page as I sped away from my beloved. I continue to re-read it every year, *comme il faut*. You may take good comfort from *"A Clear Midnight"* if I am not here to hand you the Whitman volume with a tight hug and a kiss.

Read all of Whitman's poems now. Or read them later. But please read them at some time, and celebrate. Celebrate life. Celebrate love. There will be too many losses you will have to endure, too many tortures and torments and terrors. Look for JOY in every single tiny little thing which makes you tingle, laugh and sing, appreciate and celebrate. Yes, dear, please do

your grandmother the grandest of favors and make Joy your Destiny!—E.

Acknowledgements

The Art Institute of Chicago offered me my first glimpses of Vincent van Gogh's paintings as a child and then provided me with quick glances or hours of pleasurable gazing throughout the years, for which I am heartily grateful. I am particularly thankful for the extraordinary exhibition, "Van Gogh and Gaugin: The Studio of the South," shown in Chicago from September, 2001 to January, 2002. This exhibit, capturing the idea of, and the need for, artistic collaboration, inspired me to visit Arles and Saint Paul de Mausole in Saint-Rémy-de-Provence that summer.

Reading Alice Walker's poem, *If There Was Any Justice*, shifted my thinking about Vincent, from a troubled Dutch painter with a

slashed ear to welcoming him as a cherished and talented friend.

My research led me through a wide range of topics, facilitated by Google's scanning of nineteenth-century texts once preserved in renowned academic and public libraries and now made available for study in my office. Though I read numerous books about van Gogh, the three-volume collection of Vincent's letters, executive editor Vincent W. van Gogh, to his brother Theo was invaluable and compelling.

Special thanks to Mary Pope Osborne and her Magic Tree House books for the pleasure and knowledge they have given my grandson, Sage. Most specifically, *Night of the New Magicians* sparked my grandson's lively description of Jack and Annie attending the 1889 *Exposition Universelle* in Paris. His seven-year old boy's delight and enthusiasm revived my flagging editing efforts. I am grateful too for my daughter's willingness to meet me in Paris so that I was able to accompany Sage on his first visit to Paris and the Tour d'Eiffel.

I appreciate all my dear friends who helped me through the birthing process. Special mention to Sara Slack, an artist, who taught me many years ago to look closer and work harder, but who passed away before she was able to read my manuscript. I appreciate the companionship of Carol Horning for our many museum adventures over the years, and I am especially grateful for Carol's insightful feedback and proofreading prowess. I am thankful to Angie Lofgren and Maria Stamatopoulos for the comfort and joy of their friendship which has sustained me for many years. I also appreciate the support that my sister and her husband, Meredith and Bill Slavins, have given me, and I thank Lee Clark and Dick Chandler for their timely technical expertise.

I am forever beholden to the wise and wonderful women in my writing group, Cecelia Burokas, Anne McGivern, Linda Schneider, and Jan Tubergen, who have, individually and collectively, generously contributed to my evolving writing life and to my sense of well-being. Recognition and gratitude are also owing to our early workshop facilitators, Mary

Jo Bang, Paul J. Mooney, and Peggy Shinner, and to WOW! Press for making this publication possible.

WITHDRAWN